SECRET
WOKING

Marion Field

AMBERLEY

To my sister, Meriel Forshaw, who has always been so supportive. Unlike me,
she was born in Woking!

First published 2017

Amberley Publishing
The Hill, Stroud
Gloucestershire, GL5 4EP

www.amberley-books.com

Copyright © Marion Field, 2017

The right of Marion Field to be identified as the
Author of this work has been asserted in accordance
with the Copyrights, Designs and Patents Act 1988.

ISBN 978 1 4456 5144 6 (print)
ISBN 978 1 4456 5145 3 (ebook)

British Library Cataloguing in Publication Data.
A catalogue record for this book is available from the
British Library.

Origination by Amberley Publishing.
Printed in Great Britain.

Contents

Acknowledgements 4

Introduction 5

1. Old Woking 6

2. The Railway, the Cemetery and the Crematorium 12

3. 'New' Woking 24

4. Woking in the Twentieth Century 36

5. Famous and Infamous Residents 51

6. Woking's Iconic Buildings 60

7. Murder and Mayhem 72

8. Eating and Drinking in Woking 76

9. Woking at Leisure 81

10. A Woking Miscellany 87

Notes 94

Bibliography 95

Acknowledgements

Richard and Rosemary Christopher
Meriel Forshaw
David Heater
Stuart Herring
Derek McCrum
Kevin Parrington
Philip Perello
Pradeep Sharda
Jenny Soane
Richard Spencer
David Williams

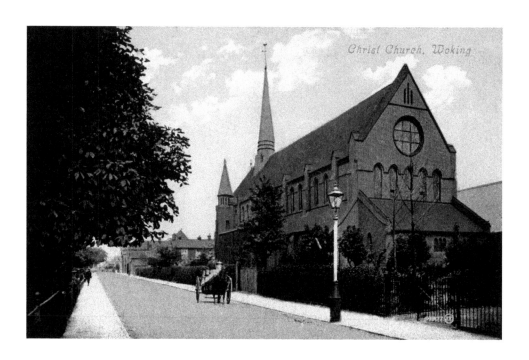

Introduction

The town now known as Woking should really be called 'New Woking'. Compared to the nearby village of 'Old Woking', it is indeed *very* new, as it did not appear until the latter part of the nineteenth century. Old Woking, on the other hand, traces its roots back several hundred years to the eleventh century and is mentioned in the Domesday Book. The eleventh-century church, St Peter's, still boasts an oak door originating in Saxon times.

I was not born in Woking, but my parents moved from Essex when I was very young because my father worked in the city and Woking has a superb train service to London. I was educated at the grammar school in Woking and later trained as a teacher. Having taught in England for a while, I then went abroad for several years. Eventually returning to my roots, I bought a house in Woking and obtained a post in a local school as a Head of English.

The town has expanded considerably since my childhood and, consequently, it has become difficult to identify the sites of the original roads and buildings. It has undergone several metamorphoses over the years and new businesses continue to appear today.

Researching old photos and taking new ones for *Woking Past and Present* was a fascinating experience and I was delighted to be invited to write *Secret Woking*. Delving into my past and talking to long-time residents of the town has been very rewarding and I hope that readers will find many details that are new to them. I have so enjoyed writing and researching this book.

1. Old Woking

'Old Woking', as it is now known, dates back to Saxon times and was originally called 'Wochingas'. According to an eighth-century document, in AD 625, a Saxon nobleman, Brordar, founded a minster in the area. A wooden church was later built on the site. By the eleventh century, the manor of Wochingas had become the property of the king. After William the Conqueror invaded England in 1066, he sent his clerks around the country to make notes on every part of his new kingdom. The result of their labours was the Domesday Book of 1086. This included the manor of Woking, which he now owned. He built a new stone church, St Peter's, on the site of the original wooden church. The huge oak door still contains a number of Saxon motives including an iron cross.

Woking was part of the royal forest of Windsor and the king and his successors often hunted in the area. In 1189, Richard I granted Sir Alan Basset the manor of Woking. It is likely that he built a manor house in the centre of the deer park. This would probably have been surrounded by a moat and approached by a drawbridge. The manor remained in the Basset family until 1280 and in the fourteenth century it reverted again to the crown. The new owner was the Duke of Kent, the king's uncle. Edmund, Duke of Somerset, took possession in 1452. He was granted a charter that gave permission for an annual fair to be held on the Tuesday after Whit Sunday. Over the years, the format of the fair changed and it became known as the 'Toy Fair'. This continued to be held until the 1870s.

When the Old Woking Village Association was formed in the twentieth century, it revived the charter fair. This was held annually during the May bank holiday weekend in

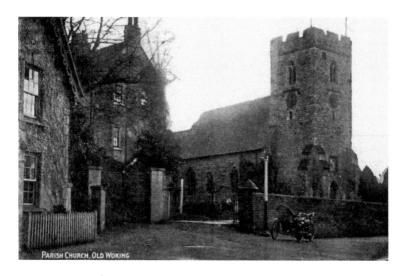

PARISH CHURCH, OLD WOKING

St Peter's Church
in the past.

the grounds of the White Hart Inn in the High Street. When the White Hart closed, the fair could no longer be held.

In the latter part of the fifteenth century, Lady Margaret Beaufort, the mother of Henry VII, inherited the manor of Woking and proceeded to transform it into a luxurious palace where she could entertain her son. It was in Woking Palace that the Treaty of Woking was signed by Henry VII. This was a non-aggression pact with the Emperor Maximilian of Austria.

Lady Margaret bequeathed the manor to her grandson Henry VIII, and when he inherited it on her death in 1509, he continued her improvements to the palace. Like his predecessors, he enjoyed hunting and he was often able to indulge in his favourite pastime when he visited Woking. He frequently entertained and it is possible that Thomas Wolsey was a guest when he heard that the Pope had elevated him to the rank of cardinal. The River Wey ran near the palace and this was probably used to ferry both freight and passengers as the palace boasted a wharf.

DID YOU KNOW?

Two of Henry VIII's wives, Anne Boleyn and Katherine Howard, stayed at Woking Palace.

Neither of Henry's daughters showed much interest in the manor of Woking and when James I inherited it, he too rarely visited. In 1618, he sold it to Sir Edward Zouche, who demolished the palace and built himself a new mansion, Hoe Place, using bricks from the palace, which was left a ruin. Sir Edward intended to leave his mark on the town. On a hill near his new house he built a 60-foot octagonal tower. Sadly, this collapsed in a violent storm in 1869, but a nearby road is still called Monument Road.

DID YOU KNOW?

The word 'hoe' is derived from an Old English word meaning 'the spur of a hill'. The Hoe stream is a tributary of the River Wey.

Sir Edward also introduced some new features to St Peter's Church. He built a gallery at the west end and installed a 3-deck hooded pulpit. In 1918, the pulpit was restored. The top part of the original structure was retained and is now the present pulpit. By 1630, the palace was a ruin and the deer park had reverted to farmland. The area became known as 'The Waste'; it was very bleak and, because of the sandy soil, little could be grown.

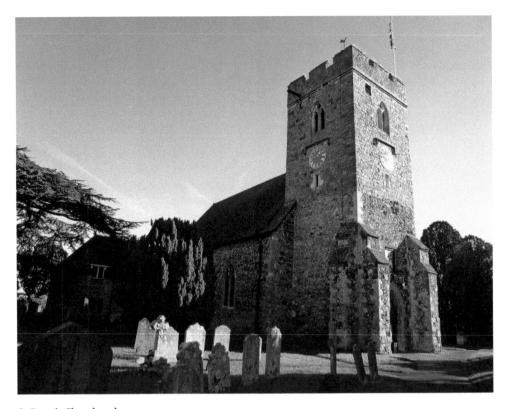

St Peter's Church today.

It also became a haunt for bandits. However, some farmhouses were built and the tenant farmers were allowed to graze their livestock, use the peat for fuel and thatch their homes with the reeds. However, they were not allowed to erect fences around their 'property' – if they did so, they would be heavily fined by the manor court.

DID YOU KNOW?

On Tuesday 28 August 1627 Charles I visited St Peter's and listened to a three-hour sermon preached by one of the king's chaplains.

It is likely that a stone chapel was built in the twelfth century on the site of the present St Mary the Virgin Church in Horsell. It was rebuilt with a nave, chancel and tower in the fourteenth century. The medieval oak doors at the west end of the church still boast the original hinges, latches and ironwork. During the following century, the south aisle was added. The succeeding centuries saw more building work, which extended the church.

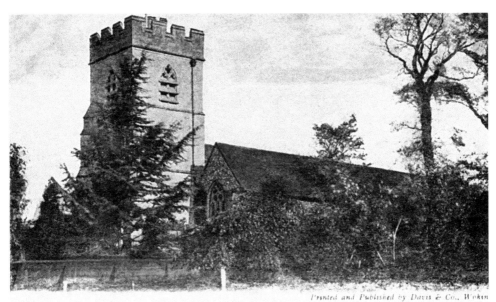

St Mary's, Horsell, in the past.

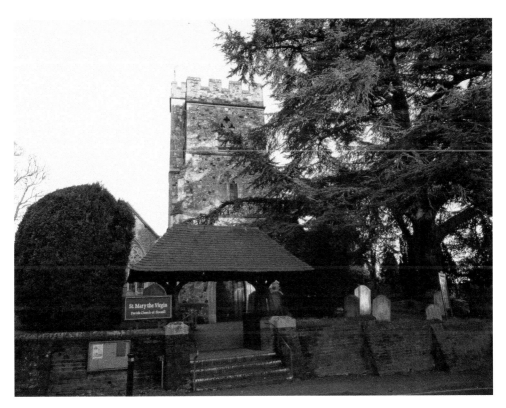

St Mary's, Horsell, today.

The Trinity Chapel and the baptistery were added early in the twentieth century and in 1987, a large room extended the north side of the church. As some of the funds for this came from the sale of St Andrew's Church – also in Horsell – the room was named St Andrews. St Mary's has six bells, which are rung every Sunday to call the parishioners to worship. They were first installed in 1741 and have been rung regularly ever since. The latest incumbent is Revd Sarah Hayes, who was inducted in October 2013.

The late seventeenth century saw the start of the development of the Wey Navigation. The area near the River Wey was improved and a small community grew up on the banks of the river at Woking. Gradually the village began to grow into a small market town, although much of the surrounding area was still farmland and forest. By the end of the eighteenth century the population had increased and Woking became a flourishing market town.

Then, in 1778, Parliament passed an act authorising the building of the Basingstoke Canal, although it was not until ten years later that work started on the canal at Woodham. The brickyards at St John's and Knaphill expanded, as local bricks were needed for building the bridges and locks. When it was completed, the canal passed under several bridges and through two locks. The original Wheatsheaf Bridge, built of local bricks, lasted until 1913 when it was replaced with metal. The canal was finally completed in September 1794 and was used for transporting timber, coal and other goods.

Although not suitable for agriculture, Woking's sandy soil was excellent for horticulture and in 1760, Goldsworth Nursery was started by James Turner. In 1800, Robert Donald, who specialized in rare trees and shrubs, bought it. In 1810, William Jackman, who

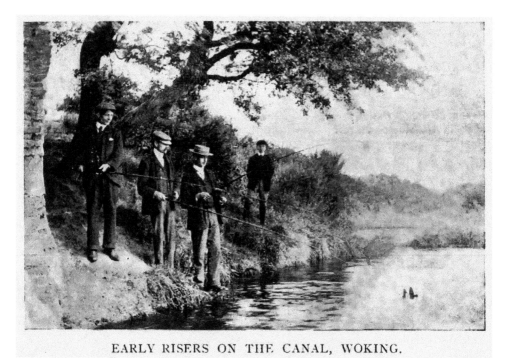

EARLY RISERS ON THE CANAL, WOKING.

Basingstoke Canal in the past.

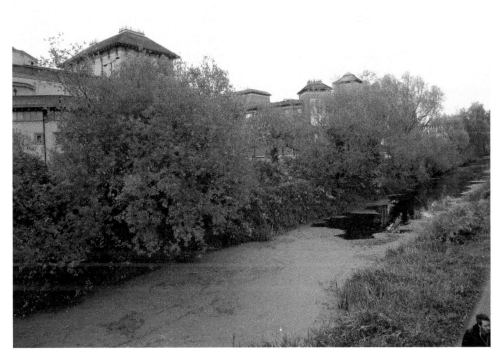

Basingstoke Canal, today.

specialized in the clematis flower, established another nursery on 50 acres of land in St John's. His sons, George and Henry, took over in 1830.

They bought more land and employed thirty-five men and six boys. While continuing to specialise in clematis, they also introduced trees, shrubs and roses. In August 1863, Jackman's Nursery won a First Class Certificate from the RHS Floral Committee for one species of clematis, the *Clematis Jaackmanii*. Later, the original land was sold for development and the nursery moved to its present site in Guildford Road. It remained in the Jackman family until 1967, when Rowland Jackman sold it to Wyevale. Today, it still flourishes under the new name of Wyevale Garden Centre.

Meanwhile, Woking had continued to grow. At the beginning of the nineteenth century, new roads had been built. However, there was a great deal of poverty, and in the 1790s, two parish workhouses were built on Westfield Common, behind St Mary's Church in Horsell. The parish vestry did its best for the poor, giving them grants for clothing and for some medical treatment. In 1822, William Freeman was appointed as 'Doctor for the Poor within 7 miles of the Town of Woking'; his annual salary was £45.

For years, tithes had been levied by the church, but these were high and unpopular. On 19 November 1830, a group of belligerent labourers and farmers gathered angrily to protest. It was Henry Drummond,[1.1] a local magistrate, who calmed the crowd and eventually persuaded them to disperse.

Before the end of the decade, Woking would have changed forever with the coming of the railway.

2. The Railway, the Cemetery and the Crematorium

In the mid-nineteenth century, the lord of the manor of Woking was the Earl of Onslow, who still owned a great deal of land. In 1834, an Act of Parliament was passed authorising the building of a railway from London to Southampton. This would pass through Woking, but the earl strongly objected to the line going across his property, although other landowners had already agreed to the proposal.

He was eventually overruled and forced to sell to the Southampton, London & Branch Railway & Dock Co. Tenant farmers who consequently lost their common rights on the land were paid compensation and, on 6 October 1834, work began on the new railway. It was an expensive project and a great deal of money was needed. Individuals and companies from all over England contributed but there is no evidence that anyone from the parish of Woking provided any help!

The chief engineer was Francis Giles, who had worked on the Basingstoke Canal. This was used to ferry the materials needed for the building of the railway. Sadly, when the railway was finally completed, the canal was no longer required and fell into disrepair. It was not until 1977 that restoration work began. In 1991, the canal was finally reopened and in August 2016 a Canal Festival was held to celebrate the 25th anniversary of its reopening. The Surrey and Hampshire Canal Society had been formed in 1966, so its 50th anniversary was also celebrated. An annual Canal Festival is held at Easter.

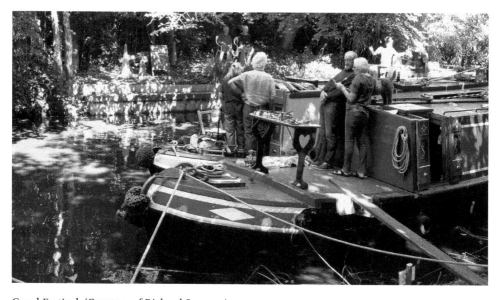

Canal Festival. (Courtesy of Richard Spencer)

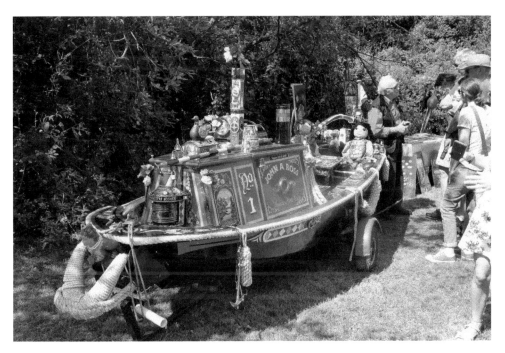

Canal Festival. (Courtesy of Richard Spencer)

In 1837 Joseph Locke, who had been a pupil of George Stephenson, replaced Francis Giles as engineer on the new railway. The following year the line was completed from Nine Elms – now Vauxhall – to Woking Common. The first journey by a number of invited guests took place on Saturday 12 May 1838. At Woking, a luxurious lunch was provided for them before they boarded the train for their return journey.

The following Saturday there was another experimental journey. On this occasion there were two trains carrying 400 passengers. Crowds turned out along the route to cheer as the trains passed by. At Woking, a number of tents had been erected nearby and here the passengers were entertained to lunch, as Woking had no hotels to accommodate them. The following Monday the railway opened its doors to the public and during the first week, over 1000 passengers made use of it. Other stations were opened along the route, with most still in use today, although some of the names have been changed. The first-class fare from Woking to London was 5s and the second class was 3s 6d.[2.1]

DID YOU KNOW?

The Necropolis Co. designed a coffin that would disintegrate quickly so the land could be used again.

The original Woking Station was a two-storey building on the Oriental Road side of the railway, and the two platforms were connected by a footbridge. As well as a booking office, a general waiting room and toilets, there was also a separate room for women and a stable block for the horses, which were used for shunting the carriages. A large bell situated on the roof of the station building was rung for five minutes before each train departed. When the line was extended to Basingstoke on 10 June 1839, a handbell replaced the larger one. The following year the line to Southampton was completed.

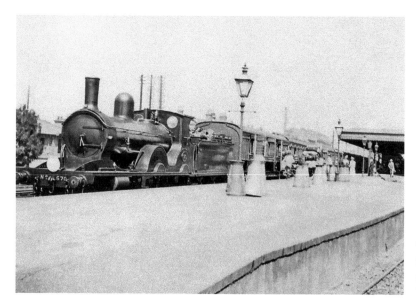

The Railway in the past. (Courtesy of Terry Gough)

Woking Station in the past. (Courtesy of Terry Gough)

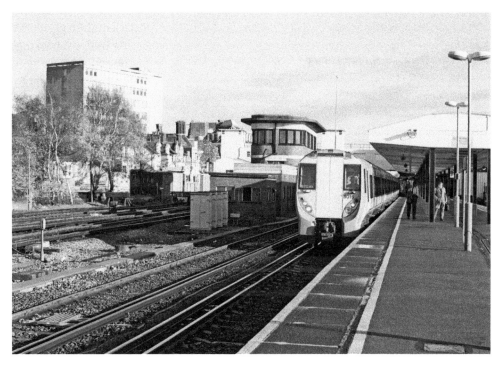

The Railway, *c.* 1970s. (Courtesy of Terry Gough)

The Railway Hotel.

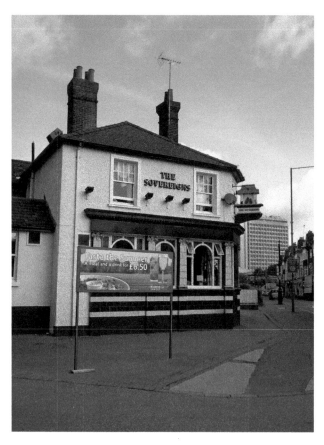

The Sovereigns.

Private carriages and horses were catered for by horseboxes and trucks. As the number of trains increased, so did the amount of traffic on the roads. Much of this passed through Woking. In 1840, the Railway Hotel was built on the north side of the railway to cater for the mail coaches that now trundled through the town. Passengers could enjoy refreshments while the horses could drink from a trough outside the hotel. In July 1848, the railway line was extended east to Waterloo Bridge, which later became Waterloo, while Woking Common became Woking. Both those names are still in use.

The Railway Ghost

Soon after the railway line opened, tradition says there was a tragedy on the line near Woking. One evening some workers were working late. One of the group was supposed to look out for approaching trains so that the men could rush to safety on the bank. Unfortunately, their companion was drunk and fell asleep. Consequently, the workers had no warning of a train and all died beneath its wheels – as did the 'lookout'.

Strangely, no remains were ever found but over the years, passers-by have heard screams and the sounds of trains, although nothing is ever seen. Apparently, the drunk man, horrified at the result of sleeping on the job, walks up and down trying to find the rest of the workers. He too is never seen, only heard as he shouts to his lost companions.

The Southern Railway Orphanage

One of the railway chaplains at Nine Elms was Canon Allen Edwards. He was very close to the railwaymen in his care and helped them in times of adversity. When one of them died and left his small daughters homeless, Canon Edwards felt something had to be done. In 1885, he rented No. 76 Jeffreys Road, a large house in Clapham, which could be used as an orphanage for railwaymen's daughters.

The first ten girls moved into the house in 1886. A resident housekeeper was found to look after them and the costs were paid by Canon Edwards. A board of managers was appointed to oversee the running of the London and South Western Railway Servants' Orphanage. Realising the importance of the venture, the railwaymen contributed funds, enabling the board to purchase the freehold of the property. They also bought the house next door, as the number of girls had increased to fifty.

In 1895 Sir Charles Scotter, the general manager of the railway company, donated £500 to the orphanage in memory of his wife, who had been keenly interested in the work. This made it possible for a third house to be bought. This one was to be used for orphaned railwaymen's sons as nothing had previously been done for the boys. In 1900, the directors contributed a further £500 and another house in Guildford Road, Clapham, was purchased. Later, the boys moved to Jeffreys Road and the girls were installed in Guildford Road.

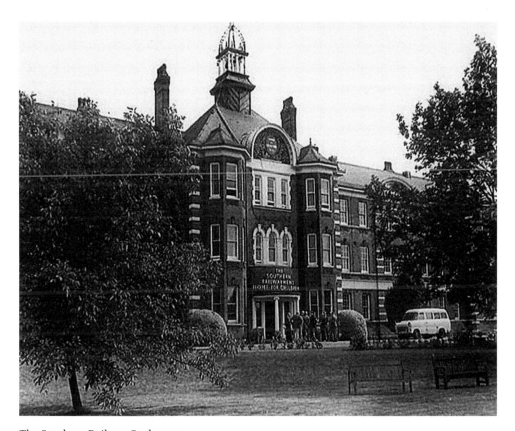

The Southern Railway Orphanage.

As numbers grew, it was decided to purchase a plot of land on which to build a purpose-built orphanage. It was felt that the children would benefit from country air after the pollution in London, so 7 acres were purchased from the London Necropolis Co. The site chosen was Woking Common near the railway station so the railway could be used to ferry the children to their new home. The foundation stone of the new building was laid on 1 October 1907 by the Duchess of Albany. The work took two years to complete. On 5 July 1909, the duchess officially opened the London and South Western Railway Servants' Orphanage in Oriental Road. In 1923, the name was changed to the Southern Railway Servants' Orphanage.

Unfortunately, over the years there was a high turnover of staff. It was difficult to recruit the right people to care for the children. The master and matron were usually husband and wife but most stayed only a short time. Some 'misbehaved' and one master left because he objected to women being 'connected with the Management of the Orphanage'. Another was dismissed because he was 'not quite right in the head'. Drunkenness also caused a problem. However, the orphanage continued and by 1929 over 900 children had passed through it and there were seventy-one boys and fifty-five girls in residence.

Fundraising continued. One interesting way of collecting money was by using dogs. Each had a collection box strapped to its back and it would walk around the station and in the train. Dogs were on the railway's payroll and were given medals to commemorate their service. Even after their death, they continued their good work. A taxidermist treated each corpse and encased it in glass. It was then placed in a strategic position on a chosen railway station to continue the good work.

Woking Homes.

On 2 November 1929, a memorial hospital was opened to commemorate old boys who had died for their country in the First World War. In 1932 a gymnasium was built. As the numbers continued to increase, there was more building – extra land was bought and used as a playing field. By 1935, there were 200 children and the sexes were strictly segregated. Their day followed a regular pattern and after doing their daily chores, they attended local schools. In the 1960s, the name was changed to Woking Grange. With the advent of social services, the number of 'orphans' in the Grange gradually diminished and by 1990 all had left.

However, the site did not remain empty for long. Its original purpose was changed and today, in 2016, instead of caring for 'orphans', it cares for a number of retired railway staff; the name has changed yet again to Woking Homes.

The Cemetery

London's population had doubled during the nineteenth century and when there was a cholera epidemic in 1848–49, churchyards became overcrowded. In 1850 Parliament passed a Burial Act closing many of the city churchyards so there could be no more interments. A new cemetery outside London was desperately needed. What better place than Woking, with its railway line surrounded by acres of common land?

At first the idea was not popular, but in 1851 the London Necropolis and National Mausoleum Co. was formed. When, the following year, it introduced a private Member's Bill into Parliament requesting permission to buy land in Woking for a cemetery, acrimonious discussion followed. One of those opposed to the scheme was Henry Drummond, the Member of Parliament for West Surrey. He cynically suggested that the company would buy a vast amount of land very cheaply, use a small portion of it for the cemetery and sell the rest at a profit. He lost the battle and in June 1852 the bill received the royal assent. A certain sum of money was given to the Woking Vestry to be shared out among the tenants for compensation.

Mr Drummond was proved right: the Necropolis Co. bought over 2,000 acres of common land but the new cemetery only covered 400 acres. The bleak heathland was transformed to a landscaped area with tree-lined avenues. Each London city church had its own plot but the cemetery was to be used by all denominations and all religions. A chapel, used for funeral services, was built near one of the new stations. The existing roads were altered to enable easy access to the cemetery and many of these still remain. On 7 November 1850, a service led by the Bishop of Winchester was held in the chapel to consecrate the Woking Necropolis now known as Brookwood Cemetery. At this time the cemetery lay in the diocese of Winchester.[2.2]

DID YOU KNOW?

In August 1997 the body of Dodi Ali Fayed, killed in a car crash with Princess Diana, was buried in the Muslim Burial Ground at Brookwood within twenty-four hours of his death. Later, he was reburied in the grounds of the Al Fayed family estate at Oxford.

Woking Station today.

In 1857 Mr John Raistrick, a wealthy railway contractor, bought over 40 acres of land on the south side of the station from the Necropolis Co. On his newly acquired land, he built an impressive mansion – Woking Lodge. George Raistrick, who inherited the estate, refused to sell any of his land for redevelopment, so 'New' Woking developed on the northern side of the railway instead of the southern side as originally planned. The main entrance to the station remained on the south side until the twenty-first century.

The Necropolis Railway

It was felt that the recently built railway line would enable coffins to travel easily from London to the cemetery. Not everyone was happy about this. The Bishop of London considered it 'improper' as the 'hustle and bustle' of the trains was 'inconsistent with the solemnity of a 'Christian burial'. In spite of this, the idea received royal assent on 30 June 1852.

Two stations were built at Brookwood to receive the coffins and mourners. These consisted of waiting rooms for the mourners, rooms for the chaplains who would accompany the coffins, toilets and an area for refreshments including a bar! The 'South Station' was reserved for those who were to be buried according the rites of the Church of England. The 'North Station' was less fashionable and catered for everyone else, including Nonconformists and those who had not been baptised. Chapels were also provided for the funeral services.

A private terminus was also constructed near Waterloo from where the 'funeral trains' would run. Work on this began in May 1854 and it was ready for use in October of that year. The building was three storeys high. The ground floor had rooms for the caretaker and the two mortuaries took up the rest of the space. The first floor contained waiting rooms and facilities for second- and third-class mourners. The top floor, level with the railway, led on to a private platform. The waiting rooms on this floor were reserved for the use of first-class passengers. Lifts carried the coffins and these linked all three floors.

A branch line was constructed to run from the terminus at Waterloo to the two cemetery stations. On 7 November 1854 a special train carried a number of VIPs on the new line to 'South Station' for the consecration of the cemetery. The ceremony, held in the Anglican chapel, was performed by the Bishop of Winchester.

Specially built 'hearse vans' were constructed to carry the coffins on the Necropolis train. Each 'van' was divided into three compartments, each carrying four coffins. This was to accommodate the three separate classes – first, second and third. Appropriate ornamentation 'to correspond with the different classes of funeral' was displayed on each. The 'hearse vans' would usually travel to the 'Morgue Chapels' at Brookwood during the night or early morning.

The crews of the trains were later provided with a lunch of bread and cheese, washed down by a pint of beer. Fares were paid by mourners and for coffins, but the chaplains who officiated at a service and employees of the Necropolis Co. did not have to pay. Daily funeral trains for the public started to run on 13 November 1854. The following day *The Spectator* commented, 'Once a day the black line will leave the metropolis for Woking; the station will put on a funeral aspect, and death will take its turn amid the busiest traffic of life.' The same magazine was also very impressed with the reverence with which the funerals, even of paupers, were conducted: 'The survivors will be able to choose the amount of black cloth, the array of feathers, the number of attendants, and the length of the ceremony but we presume that the humblest will be certain of order, decency, solemnity, and all the essentials of the last "comfortable lodgings." A Music Hall comedian did not show the same respect and produced a rather tasteless joke: 'People are dying to get into Brookwood Cemetery.'

'Class' at this time was very important and the Bishop of London had found the idea of mourners and coffins from different classes travelling in the same train 'offensive'. The more affluent first-class mourners would expect an appropriately ostentatious display to show how respected the deceased had been in life.

'Special' trains were occasionally used for the funerals of celebrities. One of these was the famous explorer Sir Henry Morton Stanley. He had a state funeral in Westminster Abbey on 17 May 1904; after this, his coffin was taken to the Necropolis Station at Waterloo. A special train carried the coffin and mourners to North Station, and here carriages awaited them for the short journey to Pyrbright Church where Stanley was buried.

A special train was also used when Dugald Drummond was buried on 11 November 1912. He had been the chief mechanical engineer on the railway. He died at his home in Surbiton from where a group of engine drivers carried his coffin to the special Necopolis

train, which had stopped at the station to receive it. Among the mourners was a group of children from the railway orphanage in Woking where Mr Drummond had been a trustee.

The Necropolis line continued to be used until 17 April 1941 when a bomb destroyed the terminus at Waterloo.

The Crematorium

Sir Henry Thompson, Queen Victoria's physician, was a founder member of the Cremation Society of Great Britain. In 1874 he became its first president. Four years later, he bought an acre of land from the Necropolis Co. near St John's village and not far from the railway line. On it he established the first custom-built crematorium in the United Kingdom. He commissioned Professor Paolo Gorini from Italy to construct a freestanding cremator. The following year this was tested successfully by using the carcase of a horse!

However, cremation was still illegal in England; it was not until 1884 that Parliament passed an act legalising it. The first human cremation took place on 26 March 1885. Although there was a great deal of hostility, this way of dealing with the dead soon became popular. More funds were raised and in 1888 a chapel containing a new cremator, waiting rooms and other amenities was added. The original cremator was transferred to Golders Green Crematorium. By the end of the nineteenth century, nearly 2,000 cremations had taken place in Woking. Later, more land was acquired and a garden of remembrance was created.

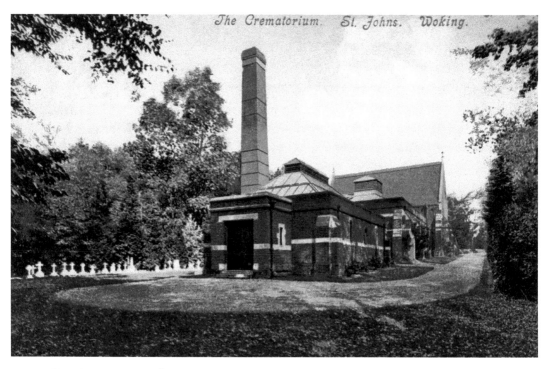

Woking Crematorium in the past.

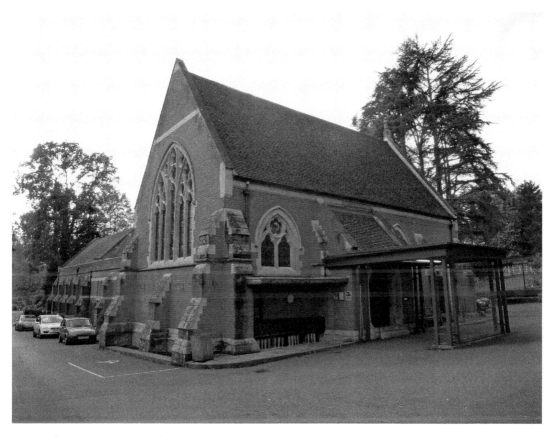

Woking Crematorium today.

In 1934, Woking obtained another first. Chamshere Jung, a Nepalese princess who had lived in St John's Village for several years, died. She was a Hindu and wished to be cremated according to the rites of her religion – this meant an open-air cremation, which was definitely illegal. Woking Crematorium applied to the Home Office for permission to fulfil the princess' wishes–this was granted and a cremation licence was issued. Woking is the only crematorium ever to have held such a licence. Princess Chamshere Jung was cremated in the grounds of Woking Crematorium in July 1934 according to Hindu custom.

3. 'New' Woking

Woking Grows

In 1855, Parliament authorised the Necropolis Co. to sell some of its land on the north side of the station. Unfortunately, the company was more interested in making money than in designing a new town. The land was divided into different sized plots, which were then sold at auction. Consequently, 'New' Woking developed in a very haphazard fashion as there was no overall planning.

In 1856, the Albion Hotel was built by Reuben Percy opposite the station on the north side. Rebuilt in 1897, it was finally demolished in 1965. Albion House, built on the same site in 1968, was later replaced by a number of shops but still has the original name. During the 1880s, shops also started to appear in Chertsey Road, the High Street and Chobham Road. In 1869, the Red House, another hotel, was built on the corner of Chobham Road and Chertsey Road. In 1936 this too was demolished and replaced by yet more shops.

The Albion Hotel.

Albion House.

Woking was becoming a popular place to live and more houses were built to accommodate the growing population. One of the estates developed at this time was Hook Heath. Its original Old English name was *La Hok* meaning 'a spur of land'. In 1892 a golf club was started there by a group of London barristers. In the nineteenth century, most golf clubs were by the sea, so Woking was one of the first to boast an inland golf club. It opened in 1983 and is still in regular use.

At the beginning of the nineteenth century, Horsell was common land where cattle grazed but in the 1880s much of the land was sold for development. Once again, there was no overall pattern for the village and the houses varied from semi-detached buildings to more luxurious detached houses.

Kiln Bridge, now St Johns, had developed in the eighteenth century because of the brickyards, which had been established because of the local deposits of clay and sand. When the Basingstoke Canal was built, local bricks were used to build the necessary bridges. Wheatsheaf Bridge in Chobham Road was demolished in 1913 and replaced with a metal one, which is still in use. Monument Bridge, named as a result of Sir Edward Zouch's Monument, was rebuilt in the 1930s.

Inns and Hotels
With the building of the railway, inns were established to serve the travellers. The Wheat Sheaf Inn was built opposite the Wheatsheaf Common and, in 1849, Reuben Percy, who had built the Albion Hotel, became landlord. The inn later became a hotel and has since

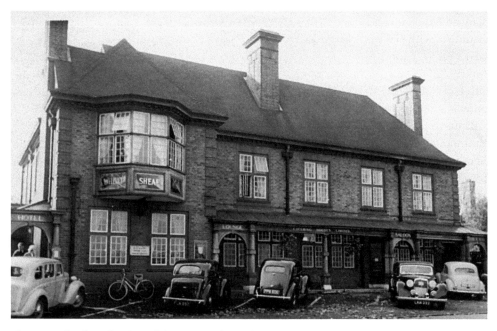

The original Wheatsheaf Hotel. (Courtesy of David Rose)

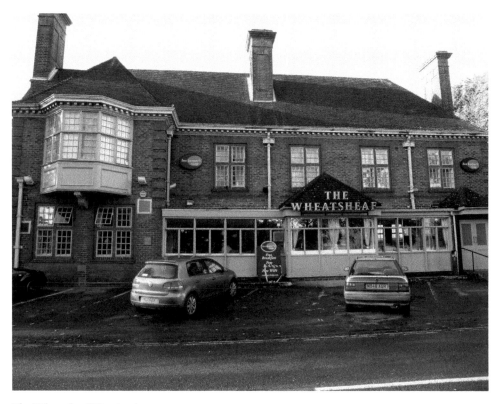

The Wheatsheaf Hotel today.

changed hands several times. Today, it is part of Ember Inns and continues to provide its customers with accommodation and a varied menu.

In 1891, Vernon Robinson took over as landlord of the Mayford Arms on the Old Woking Road. In 1905, he demolished the cottage next door and built a new inn on the site. This still serves the community. The original Mayford Arms is now a private house known as 'Friars'.

Bleak House, on the Chertsey Road, was built in the late nineteenth century on open common land. This was so 'bleak' that it seemed an appropriate name for the inn. Since then, houses have been built nearby and it is no longer 'bleak'. However, it was not until it was sold in 2004 that the name was changed. The new owners christened it 'Sands', reminiscent of the sandpits on Horsell Common.

The original Mayford Arms. (Courtesy of Rosemary and Richard Christopher)

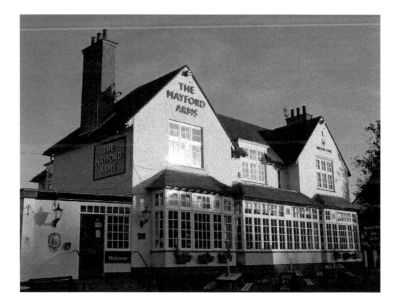

The Mayford Arms today.

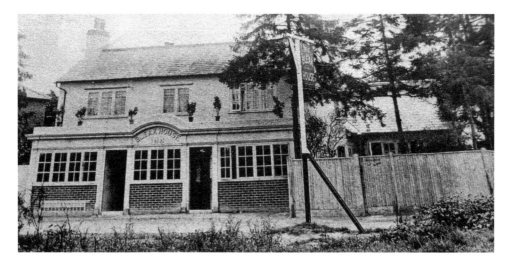

Bleak House.

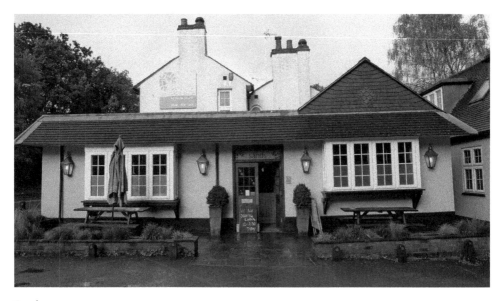

Sands.

DID YOU KNOW?

In 1715 Woking Village Brewery was founded by the Strong family at the bottom of Church Hill, Horsell. Although the brewery closed in 1887, the brewer John Stedman continued to ply his trade until 1914. While there is no brewery today, the name 'Brewery Road' is a reminder of the past.

Places of Worship

New churches in Woking also appeared during the nineteenth century. In 1815 a small Baptist chapel was erected on the edge of Horsell Common. This building was renovated in 1907. In 1963 it was sold to a Brethren group and continued to be used as a place of worship until the 1980s when it was demolished. A private house, Chapel Corner, now stands on the site.

As Kiln Bridge had grown in population because of the brickworks, a new church was necessary. In 1842 a small chapel of ease, connected to St Peter's Church, was built. This was dedicated to St John the Baptist and the village changed its name to St John's. In 1883, it became a parish church in its own right and today has a large congregation and provides a number of activities for the community during the week.

There was still no church in the town centre of Woking. There was an empty site waiting for it but money was needed to build it. Meanwhile, services were held regularly in a shop in Chertsey Road. When the congregation became too large, a temporary building, known

Baptist Chapel, Horsell.
(Courtesy of David Rose)

Chapel Corner on site of chapel.

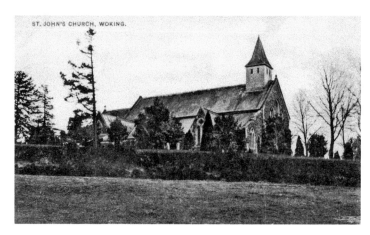

St John's Church in the past.

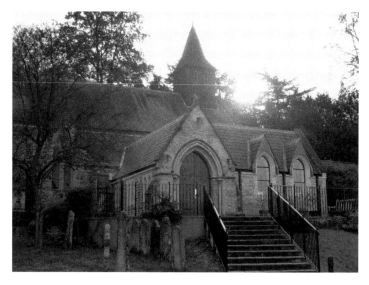

St John's Church today.

as the Iron Room, was built on the empty site in 1877. Although this could accommodate a congregation of 400, this was also soon overcrowded.

Eventually enough money was found to start building a new church and on 10 November 1887, the Duchess of Albany, a daughter-in-law of Queen Victoria, laid the foundation stone of Christ Church. The building was finally completed in 1893. The consecration service was held on 14 June and the Bishop of Winchester preached.

The first vicar of the new church was William Hamilton. Christ Church is still a flourishing town church providing services and a variety of activities throughout the week. Later, chairs replaced the pews and a popular coffee shop was installed at the west end of the church. Lunchtime concerts are often held.

In 1883, St Peter's Convent was built in Maybury to provide accommodation 'for such of the sick poor as are members of the Church of England and require nursing'. It was run by nuns of the community of St Peter, an Anglican order. In 1908 a chapel was built in the grounds.

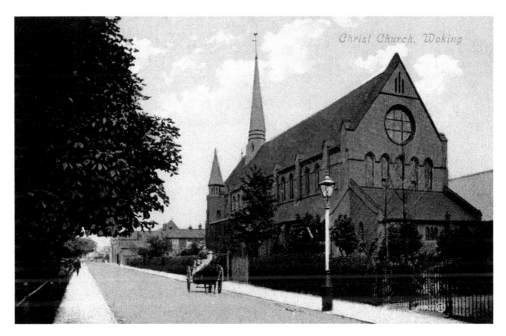

Christ Church in the past.

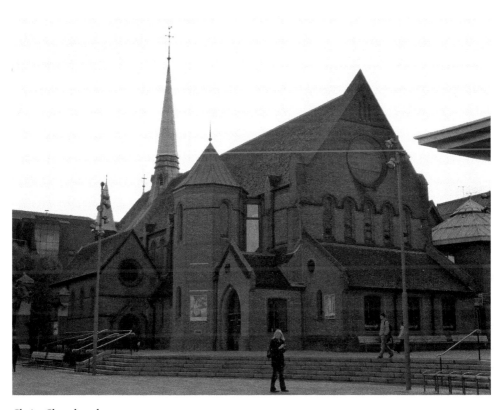

Christ Church today.

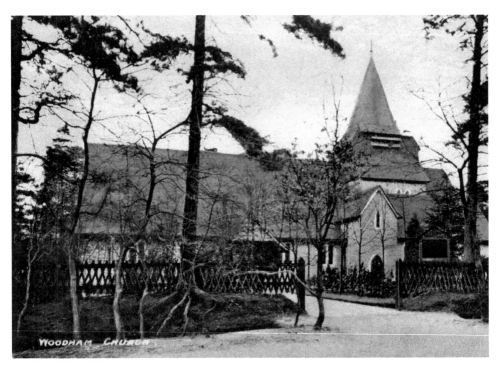

Woodham Church in the past.

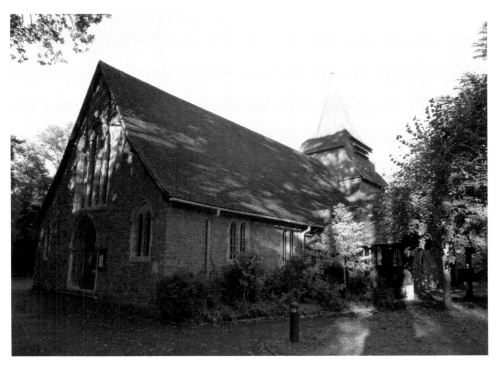

Woodham Church today.

The convent was sold at the end of the twentieth century and the buildings were converted into flats. More buildings were built in the grounds and the area was named Convent Close.

Two other churches were built during the end of the nineteenth century. In 1893, the foundation stone of All Saints' Church was laid in Woodham Lane. The church was finally completed in 1907 and still has a flourishing congregation in the twenty-first century. The population of Maybury was growing and in 1884 the foundation stone of St Paul's was laid in Oriental Road. The church was completed and consecrated the following year. Known at first as the 'Church in the Trees', it was a daughter church of Christ Church but became a parish church in 1959. It continues to serve the people of Maybury.

Unwin's Printing Works

There were other developments in Woking during the nineteenth century. In 1819, Jacob Unwin set up a printing works on the site of a disused Saxon watermill on the Old Woking Road – this had been recorded in the Domesday Book. The firm continued to flourish on the same site until the twenty-first century when it was taken over by the Martins Printing Group.

Prisons

Because there was still land for sale in the Woking area, the Home Office decided it would be an ideal place to build a prison for prisoners in need of medical care. Prison conditions at this time were appalling. 65 acres of land in the Knaphill area were bought from the Necropolis Co. Gangs of prisoners were used to build the prison, which was surrounded

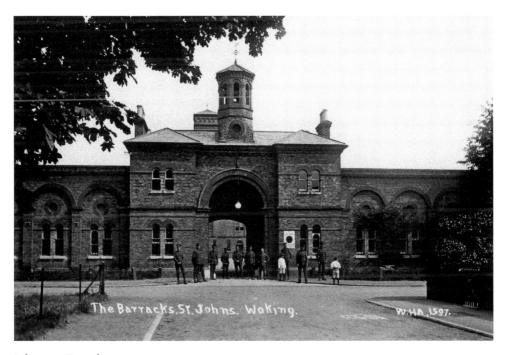

Inkerman Barracks.

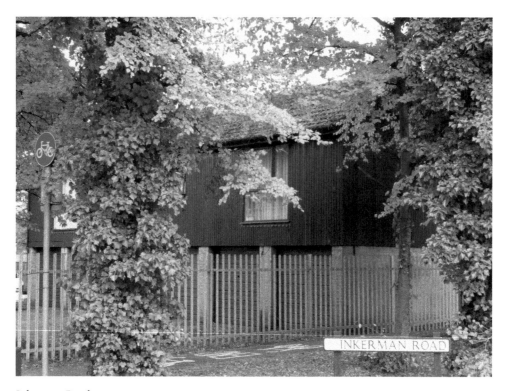

Inkerman Road.

by an 18-foot-high wall. There was a separate wing for the chronically ill. The prison was completed and officially opened on 22 May 1860, housing 300 prisoners, both male and female. The prisoners were not allowed to be idle. If they were fit enough, the men worked at maintaining the buildings while the women cooked and cleaned. In 1867, a second prison was started to house the female prisoners. Opened in 1869, it held seventy women.

The male prison closed in 1889 and in 1895 the Royal Engineers took possession and renamed the building Inkerman Barracks. The female prison closed in 1899 and became the quarters for the Royal Artillery. The army continued to use the barracks until 1965 when they were taken over by Woking Borough Council. Inkerman Road remains today as the only reminder of the army's presence.

In 1863, another building was built to house the mentally ill. Brookwood Hospital was completed in 1867, and by the end of the nineteenth century, it contained over a thousand patients of both sexes. The hospital continued to function well into the twentieth century. It closed in 1981 when most of the buildings were demolished and replaced by a Sainsbury's supermarket.

Newspapers

A very different development took place in October 1884: the *Woking News* was published for the first time. Its editorial policy was to 'be neither Conservative nor Liberal but [would] assume and maintain an attitude of perfect independence'. The following year a

rival paper, the *Woking Mail*, appeared. This aimed to be 'entertaining' and copies of the first issue were free 'with the proprietor's compliments'. When both papers were bought by the *Woodbridge Press*, they became the *Woking News and Mail*. This was bought in 1964 by the *Surrey Advertiser Group*. In the twenty-first century, it disappeared for a while but it is now back on sale every week.

More shops also grew up around the town, and in 1890 the Woking Electricity Supply Co. opened its doors in Chobham Road. At the other end of the town, Jackman's Nursery, started at the beginning of the nineteenth century, continued to flourish. In the town centre, shops and cafes were established. A bank stood on the corner of the Broadway and Chertsey Road, next to the post office.

In 1897, the foundation stone of a new hospital was laid in Chobham Road next to the Wheatsheaf Bridge. As it was Queen Victoria's Diamond Jubilee that year, the hospital was named after her. The Victoria Cottage Hospital continued to serve the people of Woking until 1990 when it was demolished and replaced by an apartment block. A new community hospital was established in Heathside Road.

4. Woking in the Twentieth Century

Queen Victoria died in 1901 and the twentieth century began. Victoria Arch in Guildford Road was named in memory of the late queen. Nearby another memorial was established in 1905. Victoria Gardens was a small park to the east of the railway arch and at the end of the High Street. Later, it was renamed Sparrow Park as flocks of the birds were attracted to it.

Victoria Arch in the past.

Victoria Arch today.

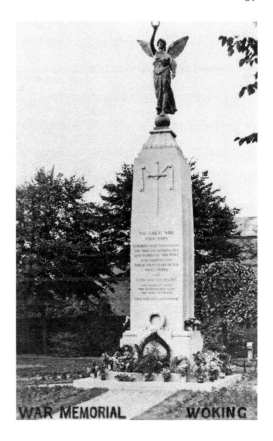

The War Memorial in the Park. (Courtesy of David Rose)

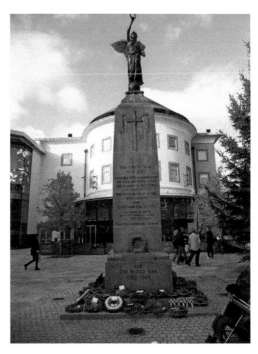

The War Memorial today.

In 1922 a war memorial was erected in Woking Park at the south end of the town. Later it was moved to Sparrow Park where it remained for over fifty years. In 1975, the memorial was thoroughly cleaned and on 21 April that year it was ceremonially hoisted into its present position in the centre of the town square. On 11 May, draped in the Union Jack, it was unveiled by the Lord Lieutenant of Surrey in front of a huge crowd. A service led by the vicar of Christ Church followed.

There were more developments on the south side of the railway when land in Pembroke Road was sold in 1909 to William Tarrant, a builder. By 1912, he had built twenty-eight houses and the following year he erected four stone pillars at the entrance to the Hockering estate. Another very different estate developed near the railway line after the Second World War. The area had originally been a lake, which had been drained. In the 1950s, Londoners who had been bombed out of their homes moved into the houses that had been built in the new Sheerwater estate. Shops, schools and a church followed as Sheerwater grew into the flourishing community it is today.

The Woking Council

During the eighteenth and nineteenth centuries, a parish vestry was responsible for the administration of the area and for looking after the poor. In the 1790s, there were two workhouses, which were always full. In 1822 William Freeman was appointed as the 'Doctor for the Poor within seven miles of the Town of Woking'. He was paid £45 a year. Vestry business meetings were held in one of the local Inns. The White Hart in Old Woking was a popular venue. The vestry met weekly to deal with parish business. It was the forerunner of the parish council and went through several changes before Woking Urban District was formed in 1895. Its offices were in the Broadway above Ashby's Bank. When the building was destroyed by fire in 1899, the council moved to Commercial Road. However, it was not until 1905 that a new council building was erected.

In 1933, the council applied for a Charter of Incorporation as a 'Borough' but it was refused. The same happened when a second petition was submitted in the 1950s. It was

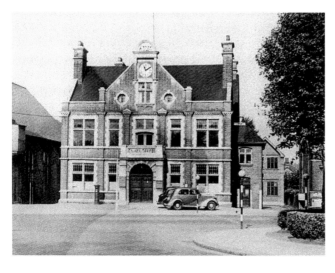

Council Offices, Commercial Road. (Courtesy of David Rose)

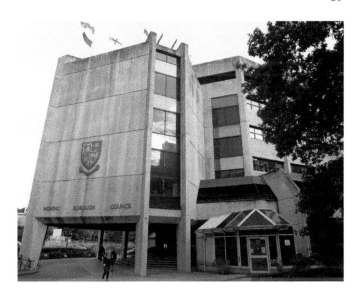

Today's Council Offices.

not until 1974 that royal assent was at last obtained for Woking Urban District Council to become elevated to a borough council.

David Robinson, the chairman of the district council, collected the parchment of the royal charter from the Houses of Parliament. The Royal Seal was attached. This portrayed the queen on both sides. On one side, she is shown in Westminster Abbey and on horseback during the 'Trooping the Colour' ceremony on the other.

Woking was now entitled to elect a mayor. Each member of the current council had a vote but it had to be unanimous. Fortunately it was, and Christopher Meredyth Mitchell was duly elected as Woking's first mayor. The local company Kennedy & Donkin, of which he was a director, presented him with his mayoral robes. These were made of fine scarlet cloth trimmed with musquash fur and lined with white silk. An Irish-lace jabot round the neck completed the outfit and red ribbons were attached to the lapels to support the heavy chain of office. The mayor's headgear was a cocked hat crowned with a golden loop. Ede & Ravencroft, robe makers and tailors to the royal family, made the robes, which cost £199. The robes are worn on all ceremonial and civic occasions including council meetings.

These are held in the Council Chamber, which is circular and councillors sit in a semicircle facing the mayor, who has a special chair. On the wall opposite him is a portrait of the queen as the mayor represents the crown. He or she signs legal documents on behalf of Her Majesty.

Behind the mayor's chair is a stained-glass window representing the various aspects of Woking. At the top, the blue with vapour trails is a reminder of the town's closeness to Heathrow airport. Wavy lines in the middle are the railway line, the brown glass below depicts the urban area and the lower blue section is the canal.

The chain of office is always worn by the mayor when on official business. This would previously have been worn by the chairman of the Chamber District Council. Each new incumbent was presented with a gold badge bearing his name, which would then be attached to the chain. It bore the Woking coat of arms that had been presented to

the town in 1930. The shield shows links with Woking's past. At the centre is Edward the Confessor's cross and the red and gold is a reminder of the Bassett family who were granted the manor of Woking by King John – the frets[41] are from the coat of arms of the next holder of the manor while the fleur-de-lis is from the fifteenth century Beaufort coat of arms. Beneath the shield are the Latin words *'Fide et Diligentia'* (Faithful and Diligent). The first mayor of Woking was presented with his gold badge of office by James Walker & Co., a local packing firm. The current chain is worth £80,000!

The other piece of regalia needed for ceremonial occasions is the mace. This, made by Shaw & Sons of London, was presented to the new borough by Mr Long, a director of the Norwich Union Insurance Co. Made of silver guilt and weighing 7 1/2 lbs, it is 44 inches long. The head of the mace, bearing the Woking coat of arms, always faces the front when carried in procession. This is a reminder that the mayor serves the people of Woking. On the other side is the royal coat of arms. This faces the mayor to remind him or her that they represent the queen. In the past, it was used for protection – particularly to save the very valuable chain of office – but today it is merely a symbol of authority. The first mace bearer was Ron Simms, who held office for forty-two years until he retired in 2015. His blue and white robes were also made by Ede & Ravencroft.

The first female mayor was Mrs Margaret Gammon, who was elected in 1980. She wore the same robes as her male peers but, instead of the cocked hat, she wore a black tricorn hat decorated with gold braid.

During the 1980s, the town of Woking was again redeveloped. The Council House in Commercial Road was demolished and a new building was erected in Gloucester Walk opposite the canal. It was officially opened on 20 April 1983 by the Duke of Gloucester. On the side of the building is the Woking coat of arms and St George's flag flies over it.

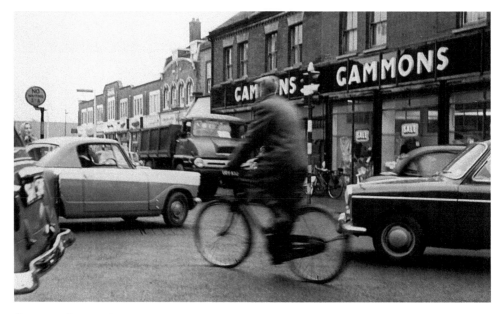

Gammons Drapery Store.

James Walker

Helmut Paul Martin and George Harris Harasyde were both engineers fascinated by aeroplanes. In 1910 they rented a shed at Brooklands to build their monoplane that, to their delight, flew 300 yards. In 1915 they became registered as Martinsyde Ltd – a combination of both their names. The same year they bought 10 acres of land around the derelict Oriental Institute in Oriental Road. The original building was demolished. Their planes were used during the First World War. After the war, Martinsyde changed their production to motorcycles.

The factory eventually closed and, in 1926, the buildings were taken over by James Walker. He was a Scottish engineer whose packing company, founded in 1882, produced high-pressure seals and other packing materials that protected the goods. The packing was marketed under the name of Lion Brand, which eventually became inextricably linked with James Walker.

Oriental Institute.

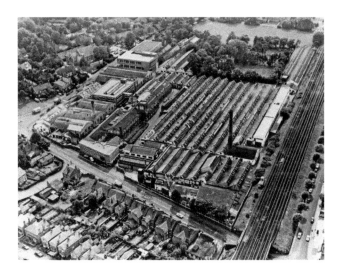

Aerial photo of James Walker.

Entrance to James Walker.

Retail Park.

Lion House.

In 1926 the thirty-strong workforce moved to the deserted Martinsyde site in Woking and the Lion Works continued to flourish on the same site until 1993, when the factory closed. The area is now occupied by the Lion Retail Park. Lion House, next to the retail park, is still the headquarters of the packing firm, although its factories are situated elsewhere.

Education

During the late eighteenth and nineteenth centuries, churches provided Sunday schools where children from poor families learnt to read. The teachers used the Bible as a teaching aid and the children were taught about the Christian faith. In 1870 Parliament passed an Education Act. 'School Boards' were created to establish schools in deprived areas. Members of the board were elected from individuals of status in the community. The money was provided from local taxes. The religious teaching provided was non-denominational. It was not until 1874 that a board school was opened in Maybury. Board schools were abolished in 1902. During the next few years, a number of primary schools were established in the Woking area. There were also several private schools.

In 1910 land was bought in Guildford Road where the first secondary school for boys was built. The building was completed in 1914 and in September the Boys' Secondary School opened with around fifty boys. There were 150 applications for the post of headmaster and the successful applicant was Mr Joshua Holden from Yorkshire. Under his leadership the school grew.

In 1918 Reginald Church, one of the masters, formed a drama group and in March of that year the school put on a performance of Shakespeare's *Twelfth Night*. Following the bard's tradition, the female parts were played by boys whose voices had not yet broken. The production was a great success and a tradition was born. The boys' school continued to produce an annual play for many years.

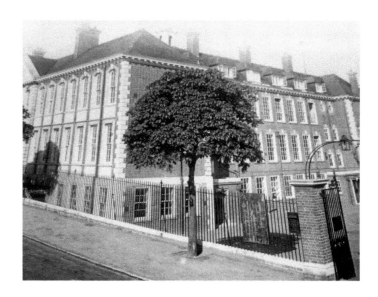

The Boys' School.
(Courtesy of Surrey
History Centre)

The school continued to grow and by 1932 there were 331 boys on the roll. Mr Holden, the first headmaster, retired that year. At the annual Speech Day he was presented with a set of the *Encyclopaedia Britannia*. Later, a memorial window dedicated to him was inserted above the balcony in the school hall. Mr Huggins from St Albans was appointed as the new headmaster.

By 1949, the school had changed its name to the Boys' Grammar School. This was the last year that Reginald Church produced the annual school play. He decided to direct Shakespeare's *Merchant of Venice*. The news of the school's excellent productions had spread and, on this occasion, the audience included a number of distinguished visitors including the Norwegian ambassador. He was so impressed that he invited the group to take the play to Norway and perform in the state theatre in Bergen.

During the Easter holidays, the drama group, with the current headmaster, Mr Humphreys, and Mr Church, travelled to Norway. It gave four performances in Bergen and then travelled to Oslo. Here, the group performed five times in the new theatre. The first performance was attended by Crown Prince Olav and his three children. Also present was the British ambassador. Their final performance was in the high school in the village of Voss.

When the school returned for the new year, Mr Ian Alexander took over the drama group and continued the tradition of the annual play. Shakespeare was still performed but more modern plays were also introduced.

The Police Station.

Sadly, the life of the Boys' Grammar School was drawing to its close. In 1976 the 55th and final play was performed in the school hall. Directed by Ian Alexander, it was *A Man's House* by John Drinkwater. Mr Alexander retired at the end of the year to train as a minister in the United Reformed Church. Among the audience at the last performance was Terry Hands, a former pupil. He had starred in many plays at the school in the past. His enthusiasm for drama had blossomed and he had chosen the theatre as a career. At this time, he was the assistant director of the Royal Shakespeare Company.

Woking Boy's Grammar School eventually closed and merged with the Girls' Grammar School to become a sixth form college. A new purpose-built school was erected in Westfield. The site of the boys' school was taken over by the police, and on 18 October 1990, the Duke of Gloucester opened the new police station and court complex.

The Girls' Secondary School

Education for girls in Woking developed later than it did for boys. When it was eventually decided that a new secondary school for girls was a necessity, there was no proper building for it. Nevertheless, on September 1923 the Girls' Secondary School opened. There had been 160 applicants for the post of headmistress and the choice eventually fell on Miss Katherine Maris, who had graduated from Newnham College, Cambridge, with a first-class degree in science. She was not too impressed with the temporary accommodation that would house her school. This was four huts erected for the army during the First World War. The huts were linked by covered pathways but with the sides open to the elements. When the sun shone, the girls could enjoy sauntering from one classroom to another but during the winter, they had to battle against wind, rain and snow.

They had plenty of exercise on games afternoons, as there was no room for playing fields near the huts, although space had been found for some tennis courts. To play

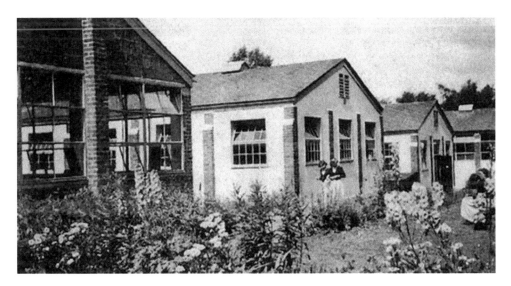

The Girls' School. (Courtesy of Dennis and Shirley Parker)

hockey and cricket, the girls had to trudge to the other end of the town near the park where there was an area for hockey in the winter and cricket in the summer. There was even a pavilion for the girls to shower after the games. When matches were held, the small kitchen provided facilities for refreshments.

In spite of the drawbacks, Miss Maris was determined to make a success of her new post. She gradually developed the embryo school into an excellent girls' grammar school. One of the huts served a triple purpose. In the morning, it was a hall and every day the headmistress would address her assembled pupils. Following 'assembly', the hall would be transformed into a gymnasium. When the last morning gym lesson had finished, tables were erected, crockery and cutlery clattered, and the area became a canteen.

In 1946, Miss Maris retired and Miss Violet Hill was appointed as the new headmistress. The Woking County Grammar School for Girls continued to flourish under its new leadership, although in 1949 Miss Hill informed the governors of the school that, 'The problem of accommodation is becoming desperate!'

Surrey County Council had submitted plans for a new building, but it was not until June 1953 that the Ministry of Education finally agreed that a new school could be built. It was five years before this was completed. At last, in January 1958, the new school was opened on the corner of East Hill and the Old Woking Road. There were two storeys encompassing a large hall, laboratories, domestic-science rooms, art rooms and even a sunroof! Spacious playing fields adjoined the school, so the girls no longer had to trail to the other end of the town once a week. The site of the old school was taken over by the Park School.

The Park School.

The new school could accommodate 540 girls. The intake each September would be ninety pupils divided into three classes. On the day the school opened, only the senior girls went in to orientate themselves in a 'proper' building. When the rest of the girls appeared the following day, the seniors were able to show them round.

In its new accommodation, the school maintained its excellent reputation and it celebrated its Golden Jubilee in 1973. It was a memorable year for the school as Miss Hill was awarded an OBE in the New Year's Honours list. She retired at the end of the school year and was replaced by Miss Jill Ferguson, her deputy.

However, the wind of change was in the air and comprehensive schools became the norm. In July 1975 the Girls' Grammar School closed. In September it reopened as the Queen Elizabeth II Comprehensive School. Miss Ferguson became the principal of the new sixth form college.

The Ockenden Ventury

After the Second World War, there were many displaced people in camps scattered throughout Europe. Joyce Pearce, a teacher at the Woking Girls' Grammar School, had visited camps in West Germany and had been very concerned about the plight of the refugees. She brought back five girls aged between twelve and fifteen and installed them in her home in Okenden, White Rose Lane. They were to be educated at Greenfield School and an appeal was launched for funds.

The Festival of Britain was held in 1951. As part of this, Miss Pearce persuaded the Woking District Council to support a holiday for seventeen more eastern European refugee teenagers. With her teaching colleague Margaret Dixon and her cousin Ruth Hicks, who was headmistress of Greenfield School, she set up the Ockenden Venture. This was to help refugee teenagers from war-torn Europe. It would support them through their secondary education, 'providing for their maintenance, clothing, education, recreation, health and general welfare'.

In February 1955, the Okenden Venture became a registered charity, and with help from the government and donations, more houses were acquired and an administrative staff established. In May 1959, the queen mother paid Ockenden an informal visit. She met the five original refugees and was entertained by traditional dances. This year was World Refugee Year and the Ockenden Venture expanded overseas.

Schools for Tibetan refugees were established in India; education and vocation centres for refugees were set up in Sudan, Pakistan, Cambodia and Algeria. In February 1960, the venture was registered as a 'War Charity', and in the New Year's Honours list of 1964, Joyce Pearce was awarded an OBE for her work.

By its tenth anniversary the following year the Ockenden Venture had sixteen homes in England and had helped 600 refugees worldwide. In July the film star Ingrid Bergman visited Ockenden. She had played the part of Gladys Aylward in the *Inn of Sixth Happiness*. Part of this had been filmed in Portmeirian in North Wales and local Chinese children had been the refugees. In February the following year, the star made an appeal on behalf of the Okenden Venture on the television show *Be So Kind*. She described it as 'a unique movement which sets out to give a home and education to young refugees of every race, colour and creed'.

By the end of the 1960s there were other civil wars. In December 1969, four refugee siblings from war-torn Biafra arrived at Ockenden and went to school at Greenfield. The following year their parents were able to visit them in their new home.

During the 1970s and 1980s, the Communist regime in Vietnam was harsh and many Vietnamese 'Boat People' fled to England where they were cared for by a number of charities. One of these was, of course, the Ockenden Venture. Joyce Pearce died in 1985 leaving behind her a lasting legacy. In 1999 the name was changed appropriately to Ockenden International. A specially commissioned drama about the history of the 'Venture' was performed at Winston Churchill School in 2010. Entitled *The Vision: Tales from Ockenden*, it was directed by Rib Davis.

Today, Ockenden International is a funding agency and its programmes are now run by other local agencies.

The Parachute Co.

In 1934 the GQ Parachute Co., which designed and produced parachutes, moved from its origins in Guildford to Portugal Road in Woking. Four years later a two-storey factory was built there. The company was kept very busy during the Second World War and

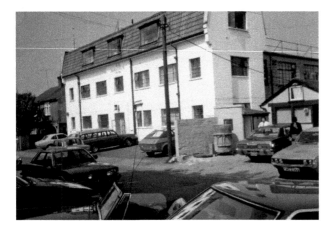

The Parachute factory.

The flats on site of factory.

continued to produce parachutes on the same site until 1987 when the company moved to South Wales. Later, a block of flats was erected on the Portugal Road site.

Parrington's Garage

Opposite the site of the Parachute Factory stands Parrington's Garage founded in the 1980s by Kevin Parrington. Kevin was born in Uganda where his father worked as an electrical engineer. The family returned to England when Kevin was ten and he finished his secondary schooling at Winston Churchill School.

When he left school at sixteen in 1970, he worked for five years as a motor vehicle apprentice at Inkerman Barracks in Knaphill. After five years, he had achieved a City and Guilds National Certificate as a craftsman and full technician. After his training, he went to America where he spent a year working with Volkswagen Cars in Minneapolis. He then returned to England ready to set up his own business.

He started in Knaphill using a 'lock-up' but was then able to buy a builder's yard and house in Portugal Road. The contracts were signed on 16 September 1985 and Kevin promptly applied to the council for permission to change the site from a builder's yard to a garage. This was granted and Kevin was in business. Living in the nearby house, he worked alone for four years before taking on extra help. His first client was John Aldridge, who is still on his books. Until it closed, he serviced the cars of the workers at the Parachute Factory.

The garage expanded and clients came to Kevin from far afield because of his excellent reputation for good service, professionalism and integrity. He also buys and sells cars; his clients know that they can rely on him to provide them with the right car. Situated near the railway, it was not long before Londoners were also making use of his services. Today, Parrington's employs five staff who do services and repairs for all makes of cars. It has over 1,000 loyal clients from all over the country.[4.2]

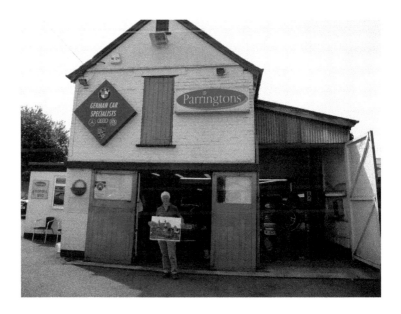

Parrington's Autos.

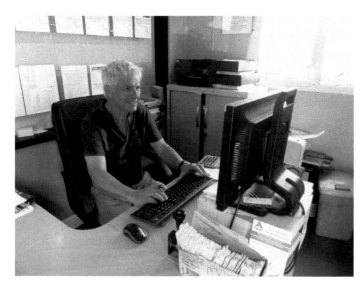

Kevin in his office.

McLaren's Racing Ltd

Ron Dennis, born and bred in Woking, was eighteen when he acquired his first car – his life-long interest in motor racing was born. He later founded Ron Dennis's Project Four Team. Another racing enthusiast on the other side of the world was Bruce McLaren, a New Zealander. In 1963 he founded Bruce McLaren Racing Ltd. Bruce died in an accident in 1970, but in 1980 his company merged with Ron Dennis's Project Four Team to form McLaren Racing Ltd. Dennis took over as team principal. He bought out the original shareholders and thus took control of the whole company. The following year the company established a factory in Boundary Road in Woking.

Dennis retired in 2009 and his place was taken by Martin Whitmarsh, who had worked for McLaren's for many years. Over the years, the company had had many successes and continued to expand, providing work for over 2,000 employees. In 2004, the company moved to an impressive new complex in Chertsey Road. The McLaren Technology Centre was opened by Her Majesty the Queen.

In September 2013, McLaren celebrated its fiftieth anniversary by displaying a number of iconic McLaren vehicles driven by Grand Prix drivers. In fifty years, McLaren's has risen from humble beginnings to become a world-renowned sporting force. It continues to experiment with new technology and today its expertise is used by many other industries.

5. Famous and Infamous Residents

George Raistrick

George Raistrick, a wealthy landowner, lived in Woking during the latter part of the nineteenth century and the beginning of the twentieth century. Although many regarded him as an eccentric, some who knew him well described him as 'a great conversationalist'. During this time Woking was starting to expand and, as the main entrance to the railway station was on the south side, Woking Council planned to build shops and houses on that side. However, Raistrick, who owned much of the land, refused to sell any of it for redevelopment. Consequently, the town of Woking grew up on the north side of the railway.

While objecting to permanent buildings being erected, Raistrick allowed a number of gypsies to camp on his land. Woking Council objected as they considered the encampment 'a nuisance dangerous to health'. When the landowner refused to have the gypsies moved, the council decided to prosecute them. Raistrick, a solicitor, was indignant and strongly defended his 'tenants' in court. Unfortunately, he lost the case.

George Raistrick died on 12 April 1905 at his home, Woking Lodge, after being ill for a few days. He left a widow, two daughters and a son. His simple coffin bore only the words 'George Raistrick died 12 April 1905'. It was taken by road to Guildford and then by rail to Brighton. The funeral service was conducted in the Extra Mural Cemetery by one of the chaplains and Raistrick was laid to rest in the family vault.

Constance Kent

In 1860 a gruesome murder was committed in the village of Road in Wiltshire. The Kent family lived in Road Hill House and it was the three-year-old son of Mr Kent's second wife, Mary, whose body had been tipped down the privy[5.1] after his throat had been cut. The press and public were fascinated by the case, but after two weeks the local police were still baffled. Had the crime been committed by someone *inside* the house or had an intruder forced his or her way in? The police contacted Scotland Yard for help and they dispatched Detective-Inspector Whicher to the scene of the crime.[5.2]

The role of a detective was a relatively new one and the press and public were annoyed that someone from a 'working-class' background had been given the authority to pry into the life of a middle-class family. However, Whicher felt it was his duty to do so but, although he identified the murderer as Constance Kent, the sixteen-year-old daughter of Samuel Kent's first wife, he was unable to find sufficient evidence for a charge and, disappointed, returned to London. It was said that the case 'almost broke the heart of poor Whicher' who 'returned to head-quarters thoroughly chapfallen'.

He was vilified in the press for daring to accuse an innocent sixteen-year-old middle-class girl of such a heinous crime. Many reporters were convinced that Samuel

Kent was the murderer because the child had seen him in bed with the nursemaid. They were wrong and Whicher was right but he could not prove it.

With the case unsolved, Constance disappeared from public view and the Road Hill case no longer dominated the headlines. In 1863 she took up residence in St Mary's Home for Religious Ladies in Brighton, but it was not until 1865 that she confessed to the Revd Arthur Wagner that it was she who had murdered her stepbrother. She could no longer live with her guilt and, in April 1865, she was escorted to Bow Street Magistrates' Court and handed the magistrate her letter of confession.

Before she left Brighton, she had written another letter that set out her reasons for committing the crime. This was eventually handed to her defence lawyer before she went to trial. She wrote that she had killed Saville because she wanted 'to avenge my mother whose place had been usurped by my stepmother'. She had not murdered Mary, she said, because that seemed to her 'too short a pang'; instead, she murdered Mary's son so that her stepmother would 'feel my revenge'.

Sent to trial in Salisbury, she pleaded guilty and was sentenced to death, but the sentence was later commuted to penal servitude for life – she would be held in prison for twenty years. During her incarceration, she was sent to various prisons. One of these was Woking, which is why she is included in this book. While at Parkhurst, she had become interested in working on mosaics, but it was while she was in Woking that she created a number of the mosaics that can be seen on the floors of several Surrey churches. However, the most famous one is in St Paul's Cathedral. It shows the face of a small boy with wings attached around his neck like a collar.

On several occasions, Constance petitioned the home secretary for an early release but her requests were always refused. She did not serve her sentence in the same prison but pleaded not to return to Woking because of 'the great dislike which for some reason or other she entertains to that prison'. She was eventually released in July 1885 after serving the full twenty years. The following year she emigrated to Australia to join her younger brother William, who had become a famous marine biologist. Having changed her name to Emilie Kaye, she trained as a nurse and worked in several establishments until she retired in 1932.

She died soon after her 100th birthday in 1844; an obituary described her as 'a pioneer nurse' and did not refer to her murky past, of which the reporter was probably unaware.

H. G. Wells

H. G. Wells was one of Woking's most famous sons, although he only lived in the town for a short time. Born on 21 September 1866 in Bromley, Kent, he was known as 'Bertie' to his family. When, at eight years old, a broken leg confined him to bed, he became addicted to books and devoured a variety of reading matter. His imagination was fired and he determined to be a writer.

In 1884 he won a scholarship to the Normal School of Science, which is now Imperial College. One of his tutors was the renowned Thomas Huxley. Sadly, 'Bertie' found it hard to concentrate on his studies and he left in 1887 without a degree. Despite this, he was able to teach until 1890 when he entered London University to study zoology and geology. At the end of his course he acquired a BSc and a teaching diploma. On the strength of

this, he stayed in London, resumed his teaching career and married his cousin Isabel. He taught until 1893 when illness forced him to retire. For the rest of his life he concentrated on writing – first as a journalist and finally as a novelist who became known as 'The Father of Science Fiction'.

He divorced Isabel and in May 1895 he moved to Woking with Amy Catherine Robbins, known as 'Jane'. He married her in October of that year. They lived in Lynton in Maybury Road until 1898. *The Time Machine*, Wells' first science-fiction novel, was published soon after their arrival in Woking and Wells was very prolific during their brief sojourn in the town. He planned and wrote a number of books and by the time they decided to move, he felt his writing career was 'fairly launched at last'.

His most famous book, *War of the Worlds*, was published in 1998. In the novel, Martians invade the town of Woking and destroy it. In the summer of 1898, soon after the book was published, the couple moved to a larger house in Worcester Park in Surrey. His fame as a writer spread worldwide and many clamoured to meet him. Jane died in 1927 and later Wells returned to London where he died in Regent's Park on 13 August 1846. He was seventy-nine.

In November 1994, a community play, *Running Red*, was performed in Woking in celebration of H. G. Wells. Like his book, it was set in the future. Four years later, in 1998, a century after the publication of *War of the Worlds*, the H. G. Wells Centre was opened in Commercial Road. To celebrate the centenary, artist Michael Condron created a stainless-steel statue called *The Martian Landing*. Around 7 metres tall, the monster's legs were set wide apart and the visor on its 'head' represented an all-seeing 'eye'. It was an excellent representation of the 'Martian'. The structure was officially unveiled on 8 April 1998 by television presenter Carol Vorderman, and Woking received plenty of coverage in the national press.

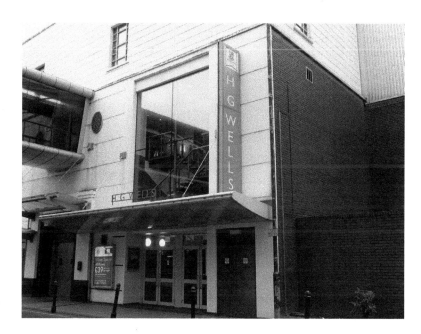

The H. G. Wells Centre.

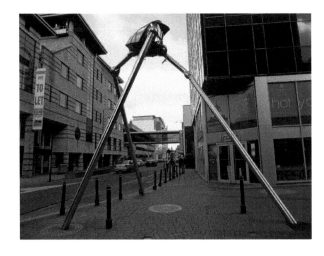

The Martian Landing.

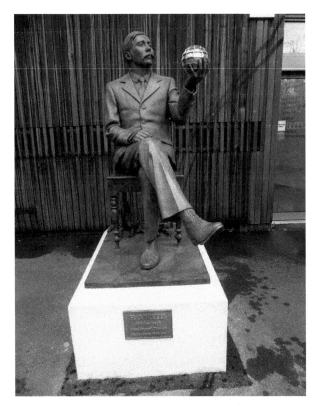

H. G. Wells, novelist and thinker.

To celebrate 150 years since the author's birth, a number of events took place in Woking in 2016: Iain Wakeford, Woking's local historian, led a number of guided heritage walks while there were talks and exhibitions at various local venues including the Lightbox and the Surrey History Centre. On 21 September 2016 a new statue, *Novelist & Thinker*, created by local artist Wesley H. Harland, was unveiled at the Lightbox Gallery and Museum.

In the autumn of 2017 it will be moved to the town centre where it will form part of the Wells in Woking Heritage Trail. Woking's famous son will not be forgotten in spite of his 'destruction' of Woking!

Madame Adelina De Lara

Lottie Adelina Preston was born on 23 January 1872. She became a celebrated musician and first performed in public in Liverpool at the age of six. Later, she attended the Hock Conservatory in Frankfurt where she studied with Clara Schumann and was friends with Johannes Brahms.

She decided very early to change her name to make it 'less English'. Her new name was Madame Adelina de Lara. In the 1930s she moved to Wych Hill in Woking where she lived for the rest of her life. She became a distinguished concert pianist, a composer and a teacher. She played in her first public concert in 1891 and continued to delight audiences for the next seventy years. During the Second World War she appeared with both Myra Hess and Sir Adrian Boult. The queen mother was one of her greatest admirers. In the King's Birthday Honours List in 1951, she was awarded an OBE. Her final performance was in the Wigmore Hall in 1954 and the following year she published her autobiography entitled *Finale*.

In 1974, on her eighty-second birthday, she came out of retirement to do a recording for a BBC television programme. She died at the Victoria Hospital on 25 November 1961 after a short illness. The Revd Michael Brettell, the Vicar of St Mary of Bethany, led the funeral service at Woking Crematorium. Her music lives on and in 2005 her suite for strings, *The Forest*, was performed in the Gloucester Academy of Music.

Captain Prestage

Captain Prestage was one of the first Salvation Army Officers to appear in Woking. He was an enthusiastic evangelist and on Saturday evening 16 March 1901, he held an open-air meeting at the junction of Chertsey and Commercial Roads. Crowds flocked to hear him but the police were less enthusiastic and he was charged with obstruction.

On Friday 19 April, Captain Prestage appeared in court at Guildford and was ordered to pay a fine of £1. This he refused to do. The police, therefore, tried to obtain possession of his goods to the same value but they found that he had no possessions as he had given them all away. He therefore had to be arrested. Unfortunately, he had been posted to Brighton so an inspector was despatched to the seaside town to bring back the prisoner!

Captain Prestage, when found, was happy to return to Surrey but, to the embarrassment of the inspector, he insisted on wearing his Salvation Army uniform. He pointed out that as the offence had been committed in uniform, he would go to prison dressed in the same way.

He spent his sentence in Wandsworth Gaol and when he was released, he returned to Woking, the scene of his 'crime'. There, he was greeted by enthusiastic crowds who watched him, dressed in prison garb, being drawn through the town in a wagon. The police were there to control the crowd but they were not needed. No more objections were raised to open-air meetings and a police officer was even posted to keep the road clear at the regular Saturday evening meetings.

A Composer and a Suffragette

Ethel Smyth, one of eight children, was born on 23 April 1858 in Sidcup, Kent. Her father, a major general in the Royal Artillery, was very opposed to her taking up music as a profession. However, she eventually persuaded him that she was serious about her music and, at the age of seventeen, she was allowed to study privately. Eventually, her father agreed that she should attend Leipzig Conservatory. She remained there a year but was not very happy with the teaching methods and left to continue studying privately.

She became a prolific composer, writing songs, works for the piano, chamber music, orchestral and choral works and operas. At the beginning of the twentieth century, she moved to Woking where she lived for the rest of her life. Woking already had a musical tradition and she became patron of both the Woking Choral Society and the Woking Musical Society. On several occasions she conducted her own compositions at concerts in the town.

Ethel Smyth had other interests. She was a keen horse rider, played tennis and was a member of the Ladies Section of the Woking Golf Club. She also became an enthusiastic suffragette. In 1910 she joined The Women's Social and Political Union. Deciding that this was more important than her music, she concentrated on the cause for two years. In 1911 she wrote 'The March of the Women', which became the anthem of the suffrage movement. On one occasion she threw a brick through the window of a politician's house and was imprisoned for two months in Holloway Prison. While the other suffragettes marched in the quadrangle singing their anthem, Ethel leaned out of her window and conducted them waving a toothbrush! She was released after five weeks on grounds of ill health.

She returned to her love of music but, sadly, started to go deaf and was only able to compose four more works before she lost her hearing completely. Unable to compose, she turned to writing and between 1919 and 1940 she published ten books based on her own life. In 1922 she was made a Dame Commander of the Order of the British Empire – the first female composer to receive such an honour. She was also awarded honorary doctorates in music from the universities of Durham and Oxford. In 1934, on her seventy-fifth birthday, her work was played in the Albert Hall but sadly she was unable to hear the music or the tumultuous applause.

In 1928, she celebrated fifty years of her work being performed in public. This occasion was marked by a concert in the Boys' Secondary School, performed by the Woking Musical Society and conducted by the composer herself. Many had no idea that she was completely deaf. The following week she travelled to Berlin for another celebratory concert. She was 'to have the very great honour of being the first woman to conduct the Berlin Philharmonic Orchestra'. The last time she conducted a performance of her own work in Woking was in 1936.

Dame Ethel died at her home in Hook Heath, Woking, in 1944 at the age of eighty-six. At her request, her brother Bob, a brigadier in the British Army, scattered her ashes near the Woking Golf Club where she had often played. In September 2007, the American premier of her opera *The Wreckers* was performed in New York by the American Symphony Orchestra.

The Bedser Twins

There is no doubt that Eric and Alec Bedser are two of Woking's most famous sons, although they were not born in the town. Eric was born ten minutes before his twin on 4 July 1918. When they were six months old, their father, a bricklayer, moved his family to Woking where they lived for the rest of their lives.

The twins went first to Maybury Junior School and then to Monument Hill Secondary School. They were members of All Saints Church in Woodham where the twins sang in the choir. They played their first cricket match when they were seven. Their talent was soon recognised and, when they were fourteen, they became members of Woking Cricket Club. One day, when practising at the nets, they were spotted by Surrey coach Alan Peach. In 1938 they joined the staff at the Oval. In June 1939 they played their first match for Surrey against Oxford University.

At the time, they were both working as solicitor's clerks in Lincolns Inns Fields but, when war came in 1939, they joined the RAF. They were sent to France with the British Expeditionary Force. They were two of the many evacuated from Dunkirk and went on to serve in North Africa, Italy and Austria before being demobilised in 1946.

The war over, they resumed their cricketing careers. Both continued to play for Surrey but Alec was also selected to play for England in the first test against India in 1946. The same year he joined the England team in Australia where he was the first English bowler to take 100 wickets against the home team. He even bowled the world-famous batsman Donald Bradman out for a duck! Later Bradman said it had been 'the best ball I faced in my whole career'. Returning home, Alec was named by Wisden as the 'Cricketer of the Year'. In April 1951 a presentation was held in Christ Church Hall to honour him. After a dinner in the Albion Hotel, he was presented with a television set. He was delighted as he said that his mother would now be able to watch her son playing cricket for England.

At the end of the school year in 1949, the Bedsers visited their old school Monument Hill for the annual prize-giving. Robert Carter, the most promising cricketer in the school, was presented with a cricket bat autographed by the famous twins.

Both continued to play for Surrey and in 1956 Surrey became champions for the fifth time. In 1958 a benefit cricket match for Eric Bedser was held at the ground in Brewery Road. Horsell Cricket Club played against a Surrey team. Eric was one of the bowlers and one of the home team hit the county bowler into Brewery Road for six!

Alec played his last test match for England against South Africa in July 1955 and the twins retired in 1960; in Alec's final game that year he took five wickets for twenty-one in twenty-one overs. After he retired, he became chairman of the selectors for the English team and president of the Surry Cricket Club. In 1964 he was awarded the Order of the British Empire and in 1982 he was promoted to Commander of the British Empire. Then, in the Honours' List of 1997, Alec Bedser received an even higher accolade as he was knighted by the queen for his services to cricket. The twins continued to live together in Woking until Eric died in 2006. Sir Alec died four years later in 2010. He has been described as 'the greatest English cricketer of the twentieth century'.

Eric Bedser.

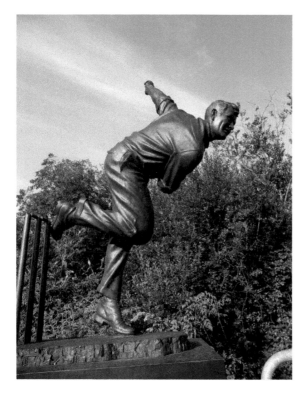

Alec Bedser.

Woking's Vet

Peter Moffett was born in 1951 in Streatham, London. Soon after he was born, the family moved to Knaphill. Then, in 1970, they moved nearer Woking town centre. Peter attended Winston Churchill School and, while there, he joined Byfleet Players and acted with them. When not acting or studying, he pulled pints at his local pub, the Wheatsheaf in Chobham Road.

Peter soon realised that his career was to be in the theatre and he gained a place at the Central School of Speech and Drama. When he left, his first job was as an assistant stage manager in Nottingham Playhouse. While there, he changed his name to 'Davison' to avoid confusion with another actor whose name was Moffatt.

During the 1970s he made several television appearances, but during a 'resting' period he worked for a tax office in Twickenham for eighteen months. His break came in 1978 when he was cast as Tristan Farnon, Siegfried's difficult brother, in *All Creatures Great and Small*. Apparently, the real 'Tristan Farnon' was a great help to Peter in creating his part. During one episode, Peter was out of breath after chasing a herd of cows.

He declined taking part in a second series, as he did not wish to be 'typecast'. In 1980 he landed the iconic part of Doctor Who, succeeding Tom Baker. At twenty-nine, he was the youngest actor to play the role. He left *Doctor Who* in 1984 and in 1988 he returned to play Tristan Farnon in a revival of *All Creatures Great and Small*.

Since then he has rarely been out of work, appearing not only on television but also in films in radio and on stage. On the latter, he played in *Arsenic and Old Lace* and *Dial M for Murder*. In 1997 he even appeared as Buttons in the pantomime *Cinderella* at the Arts Theatre in Cambridge.

In 2003, Peter Davison married his third wife, the actor and writer Elizabeth Morton, by whom he had two sons, Louis and Joel. He had divorced his first wife in 1975 after only two years of marriage. His second wife was Sandra Dickenson, the American actor with whom he worked in *The Tomorrow People*, a children's television science-fiction programme. Their daughter Georgia was born in 1984 and he divorced Sandra ten years later. In 1982 he appeared on *This is Your Life*. He had been accosted by Eamonn Andrews with his famous Red Book in Trafalgar Square while filming a promotion for *Doctor Who*.

6. Woking Iconic Buildings

St Peter's Church

During the latter part of the eleventh century, William I built a stone church on the site of the original Saxon church. The huge oval door at the west end is Saxon and displays a number of Anglo-Saxon motives, including an iron cross. St Peter's Church still plays host to a flourishing congregation on Sundays and a number of activities and meetings during the week.

On the south wall, a stained-glass window depicts St Peter, who the church is named after. The logo, created by Colin Lewis, uses this window as the central section. At the top, on the left-hand side, crossed keys represent the 'Keys of the Kingdom' given to Peter by Christ; on the right is a cockerel, a reminder of Peter's denial. Balancing these are two symbols at the bottom. The one on the right shows three fish and the one on the left depicts a fishing boat, reminding us of Peter's occupation.

The lower part of the church tower was built in the early thirteenth century. Constructed of rubble-and-pudding stone, there are blocked-up windows on the north and south walls. The upper section was probably completed in the fifteenth century. This was made of heath stone, sometimes called sarsen stone; the window surrounds, like those of Woking Palace, were made of chalk clunch.

When Sir Edward Zouch built himself a new mansion using materials from the palace, his parish church was St Peter's. Determined to be remembered, in 1662 he introduced two innovations. One was a gallery at the west end that stretched across the nave. This may have been removed from the great hall of the palace as the size is similar; however, there is no actual evidence for this as the timber used is not of a type that can be tree-ring dated. Later, the gallery was extended across the south aisle of the church. It still bears the name of its originator.

The second new installation was a three-deck hooded pulpit. This would enable those in the gallery to see the preacher. When Charles I stayed in Woking during August 1627, he attended St Peter's. On Tuesday 28 August he listened to a three-hour sermon there. In 1918 when the pulpit was restored, the two lower sections were removed and the upper section now forms the present pulpit, which is still in regular use.

Woking Palace

When Sir Alan Basset received the manor of Woking from Richard I in 1189, he built a manor house in the middle of the deer park, which consisted of around 40 acres. The building was surrounded by a moat with a drawbridge for entrance. Later a stable complex was added. Here horses, oxen and sheep could reside. There was also a poultry house where hens could lay eggs. Nearby was a brewhouse for brewing. A locksmith had charge of the wine, which was always locked up. Over the years, the manor complex expanded.

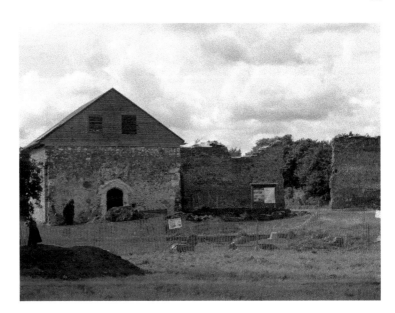

Ruins of Woking
Palace.

Ruins of Woking
Palace.

By the fourteenth century, there was a hall and two large chambers to accommodate the king and queen. Although state banquets were not held here, many important people visited in a private capacity. They would sometimes dine on the result of the king's hunting expeditions. There were also two fishponds in the park so visitors could sample fish as well as game and meat. Nets were used to trap pike and were then transported to the kitchen. The cooking facilities included a kitchen, pantry, larder and bakehouse.

The manor of Woking changed hands several times and in 1466 Lady Margaret Beaufort and her third husband, Henry Stafford, obtained it by royal grant. They lived

in the 'substantial' manor house until Henry Stafford died in 1471. The following year his widow married Lord Thomas Stanley. When Lady Margaret's son became Henry VII after defeating Richard III at the Battle of Bosworth, he frequently stayed in Woking with his mother. In 1503 he instigated improvements to the manor house, transforming it into a luxurious royal palace. His son Henry VIII continued the renovations, completing the great hall and enlarging the palace.

Henry was a great sportsman and loved to show off his prowess in a variety of sports. A mound was built in the grounds from where spectators could watch the hunt. They could also gaze at jousting, archery and falconry shows. Henry loved life and he wanted his guests to enjoy themselves. In 1537 he had two new bowling alleys built. One was 'for the king to boulle in' while the other was for 'the kyng and queen to walk in'.

Unfortunately, his successors did not show the same amount of interest in the palace and the buildings were not maintained. Then, in 1620, James I granted the palace to Sir Edward Zouch. He occasionally entertained royalty. In 1625, Charles I used it as a refuge from the plague. Soon after this, Zouch abandoned the palace altogether. It needed a great deal of repair and, instead of attending to this, Zouch used the bricks and other materials from the palace to construct a new manor house for himself. Today, Hoe Place is a Boy's Preparatory School called Hoe Bridge School. The original fishpond had been filled in but the King's Walk is now a 'Ha-Ha'. The wall still contains the 2-inch bricks that had been taken from the palace.

Over the next three centuries the palace was deserted and became a ruin. It was not until 1988 that the site was purchased by Woking Borough Council. The council gave permission for excavations, which enabled archaeologists to discover artefacts and record

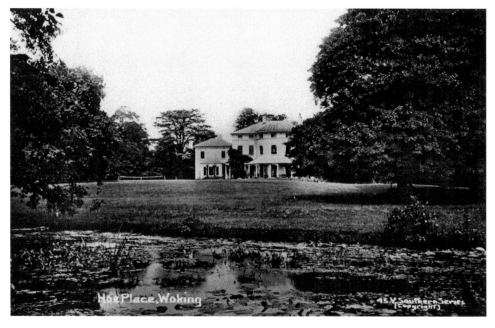

Hoe Place. (Courtesy of David Rose)

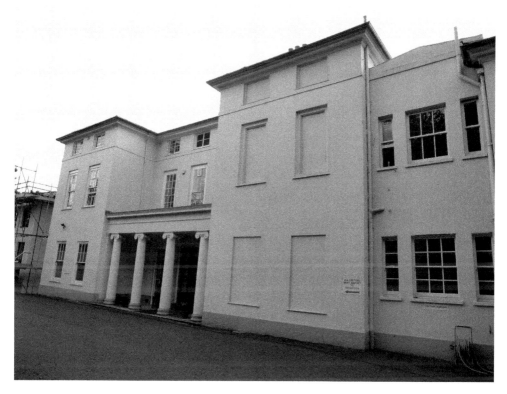

Hoe Place Preparatory School.

DID YOU KNOW?

Sir Edward Zouch, who built Hoe Place with material from Woking Palace, is said to have introduced pine trees into Woking. Today, there are still many wooded areas around Woking containing pine trees.

details of the construction and positioning of the original buildings. Today, the area is an historic site and great care is taken to preserve it.

The Mosque

In 1889 Dr Gottlieb Wilhelm Leitner transformed the defunct Royal Dramatic College into an Oriental Institute. This gave its name to Oriental Road. In the grounds of the institute, Dr Leitner decided to build the first mosque in England to cater for his Muslim students. Donations were received from Her Highness the Begum Shah Jehan, the ruler of Bhupal State in India, and many other Indian Muslims. The architect W. L. Chambers was influenced by drawings from a rare work of art, *Art Arabe,* and from other oriental

mosques. Traditional minarets surrounded the walls and on top of the blue-and-gold dome was a gilt crescent. Arabic calligraphy graced the interior. The mosque was named after its benefactor, Shah Jehan. Unfortunately, Dr Leitner died soon after the mosque was opened, so it closed and did not open again for some years.

Then, in 1912, Khwaja Karnal ud Din, an Indian barrister, left his homeland and came to England as the first Muslim missionary. He reopened the mosque and it has continued to serve the Muslim community ever since. Other buildings eventually grew up around it. In August 1915 the Muslim festival of Eid was celebrated at the Shah Jehan Mosque. Among the visitors were fifty Indian soldiers who had been wounded in the First World War. They travelled from New Milton in Hampshire

DID YOU KNOW?

On 1 June 1860, Prince Albert laid the foundation stone for the Royal Dramatic College in Oriental Road. Donations were received from theatregoers and thespians and several London theatres gave benefit performances to raise money. The new college for 'decaying actors and actresses' was opened in 1865 by the Prince of Wales as, sadly, his father had died the previous year. There was a large central hall for dining and entertaining, and nearby there were houses for the residents.

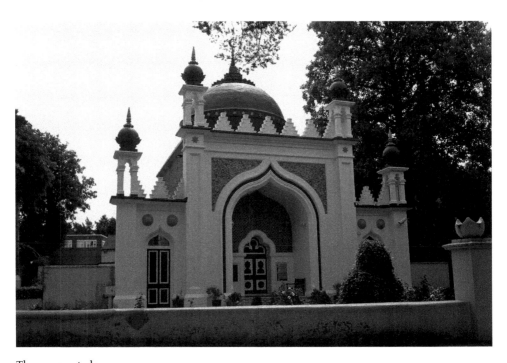

The mosque today.

where they had been convalescing. When they arrived, they changed into their traditional white robes. Over 300 people attended and the service, conducted by the Imam Maulvie Sadr-ud-din, was held outside, as the building could not accommodate such a large number.

On 9 October 1925 the mosque welcomed an important visitor. This was Her Highness Nawab Shah Jehan, whose money had contributed to the building of the mosque. She was heavily veiled and wore a jade-green dress. Muslims from many other places came to see her. After the imam in the mosque had said the prayers, she moved outside to the newly erected marquee. Here Lord Headley, the president of the British Muslim Society, welcomed her to Woking.

Ten years later, in 1936, Haile Selassie, the Emperor of Ethiopia, also visited Woking. He drove from London and was greeted at the mosque by Madam Buchanan-Hamilton, who presented him with a bouquet. She and her husband were members of the British Muslim Society. Sir Abdulla Archibald Hamilton welcomed the visitor and later the emperor was presented with a copy of the Koran.

On 21 August 1957 a memorial service for the late Aga Khan was attended by his grandson, the new Aga Khan. The service, attended by around 300 guests, was led by

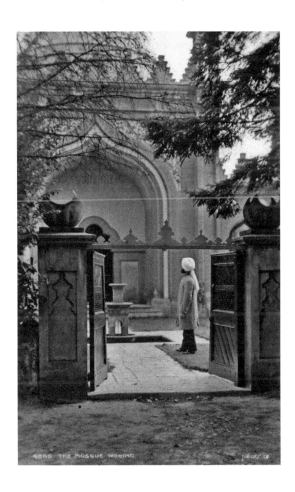

The mosque in the past.

the Imam Muhammad Yahya Butt. One of the visitors was the Earl of Scarborough, who represented the queen. He was greeted by the Aga Khan when he arrived at the mosque.

Following the Second World War and the creation of the state of Pakistan, many Muslims settled in Woking. Most lived in Maybury near the mosque. Today, the buildings adjacent to the mosque are used by children after school on Mondays to Thursdays or at weekends. Here they learn Arabic and read the Koran. On Fridays, Oriental Road is thronged with worshippers wending their way to the mosque for Friday prayers.

The Muslim Burial Ground

During both world wars, thousands of Indian soldiers left their homeland and travelled miles to fight for Great Britain against an implacable enemy. Many of them gave their lives and their remains lie far from the country of their birth. Many of those who died were Muslims and, during the First World War, German propaganda insinuated that those who died in England were not being buried with due reverence. As this was false, the British government was determined to do something to counteract it. Parliament, therefore, announced that there would be a new burial ground for the interment of Muslim soldiers. As Woking contained the only mosque in England, the town was chosen for the site. In 1915 the War Office purchased a piece of land on Horsell Common near the Basingstoke Canal in Monument Road.

The architect was T. H. White and it was built by local firm Ashby & Horner Ltd. The entrance was through a domed archway known as a Chattri. The minarets and decoration

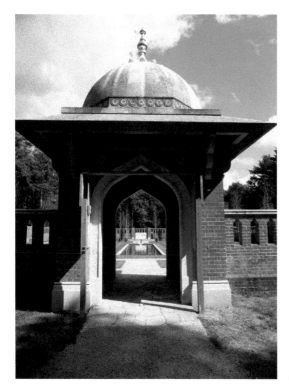

Entrance to the Peace Garden.

were influenced by the style of the Shah Jehan Mosque. Yew trees surrounded the cemetery, which was completed in 1917. Nineteen Muslim soldiers were reverently laid to rest beneath gravestones that all faced Mecca. In 1921 the upkeep of the cemetery was taken over by the War Graves Commission.

During the Second World War a further eight Indian soldiers were buried on the same site. The last soldier to be buried there was Leading Aircraftsman Youssif Ali of the Royal Air Force. While in England during the 1920s he had met and married an English girl. When war broke out in 1939, Youssif enlisted. When the war ended, he served with the British Air Forces of Occupation and died in France. He was buried in the Muslim Burial Ground on 12 May 1947. His widow and four children regularly visited his grave.

Then, in 1969, all the bodies were exhumed and reinterred in the Brookwood Military Cemetery. The Horsell Common Preservation Society became responsible for the site. Unfortunately, there was no money to restore it and over the next few years the cemetery fell into disrepair. It was not until the twenty-first century that Historic England came to the rescue. It was decided to transform the cemetery into a peace garden.

The exterior walls and the Chattri entrance were restored. On the top of the dome, a gilded finial was carved in the shape of a lotus flower and ornate oak doors were installed. The restoration of the entrance and walls was completed by the summer of 2014 and work on the peace garden began. An army of 'volunteers' was required. To provide a link with the past, members of the Armed Forces Muslim Association worked side by side with serving soldiers of the British Army and students from Bishop David Brown School. Members of the Horsell Common Preservation Society and the Shah Jehan Mosque were also involved.

By 2015 the peace garden was complete. Twenty-seven Himalayan Birch Trees represented each of the twenty-seven servicemen and each of their names is inscribed on a memorial stone. A water feature stretched the length of the garden and a number of seats beside it enable visitors to sit and enjoy the peace and tranquillity.

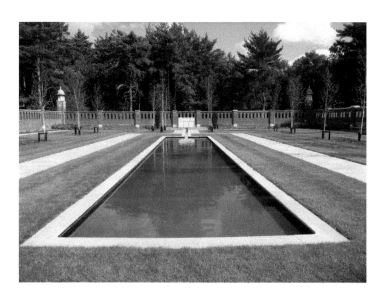

Water feature in the Peace Garden.

Surrey History Centre.

The Surrey History Centre

Goldsworth School had occupied buildings in Goldsworth Road for many years. When it moved to its new premises in Bridge Barn Lane, the site was taken over by the Surrey History Centre. An impressive new building was erected to house a variety of Surrey archives. The centre contains a collection of books, photos, documents, films and other items. It holds records relating to all aspects of Surrey's history and is open most days for those who wish to do some research. It also holds exhibitions, particularly on specific anniversaries, and is usually a hive of activity.

Salvation Army Community Church

In 1987 a Salvation Army brother arrived in Woking with some copies of the Salvation Army paper, *The War Cry*. He proceeded to sell these to intrigued passers-by. A little later, two Salvation Army 'Officers' drove into Walton Road in a 'Calvary Van'. Over the coming weeks they succeeded in creating a 'Corps' of Salvation Army members. Rooms above a shop at the junction of Church Road and Chobham Road were taken over.

There was a large room for meetings and a smaller one for the 'Officers' Quarters. The Corps was officially opened on 1 October 1897 and the first 'soldier', a 'sister', was

enrolled six weeks later. Open-air meetings were regularly held on Saturday evenings and more 'soldiers' were enrolled. In the summer a large tent was occasionally erected to house the congregation. Other public halls in the town were used but the Corps required a permanent base.

A site was eventually found on the corner of Church Street and Clarence Avenue and building started. The new Salvation Army Hall was officially opened on 8 October 1897. There was a separate hall for children's meetings. In 1898, the band was formed and this continues to give pleasure to Woking residents as it processes through the town on Good Fridays and plays Christmas carols later in the year.

During the 1890s Woking Borough Council decided it was time for some redevelopment. Church Street was on the list, so the Salvation Army lost its hall and had to search for new premises. These were eventually found in Walton Road and sufficient funds were raised to start building.

While the Corps had no permanent home, other churches in the town leant their facilities. Meetings were held in Christ Church Hall and the Methodist Church Hall, but St Mary of Bethany's Kingsway Hall became the corps' temporary home until 1972 when the new building was completed.

A final meeting was held in Kingsway Hall on Saturday 15 April and the corps then marched through the town to Walton Road where the opening ceremony was held before

Salvation Army Community Church.

a capacity crowd. For the next twenty years Walton Road was the hub of the Salvation Army's activities. Fundraising started again in 1991. Money was needed for necessary renovations to the hall. When these were completed, a service of Thanksgiving and Praise was held in the hall on 9 November of the same year.

Then, in 2005, the halls were again under threat. Once again they had to be demolished for redevelopment. It was planned to build flats on the site. When the flats were finally erected, the Salvation Army was not forgotten as the flats were named Booth Court. This time the corps found a temporary home in the Horsell Village Hall while a variety of fundraising events were held. Money was eventually raised for a new building and on 1 June 2004 Woking Borough Council gave planning permission for building to start at the junction of Bullbeggars Lane and Sythwood.

The new building was to be a community church open to all. During the building much use was made of modern technology. Solar panels were installed, there was a monodraught ventilation system and a rainwater-harvesting plant. There was a large worship area, a café in the foyer and numerous other rooms and offices.

The official opening and dedication of the Salvation Army Community Church took place on Saturday 19 January 2008. Once again crowds attended. The church continues to be in regular use by many others as well as Salvationists.

The Lightbox

In 1993, a group of local residents including members of the Woking History Society decided that Woking needed a 'cultural centre'. Fundraising started but it was some time before their dream became reality. Eventually enough money was raised to start the project. Partly funded by the Woking Borough Council, it also received some money from the Heritage Lottery Fund. The architect chosen was Marks Barfield Architects, who had designed the London Eye.

The Lightbox.

The very modern Lightbox opened on the corner of Chobham Road and Victoria Way in September 2007. However, it was in February 2008 that it was officially opened by the Duke of Kent. The same year it won the prestigious Museum of the Year award from the Art Fund. Later in 2016, the Lightbox was also awarded a Green Tourist Silver award.

The building is a square, brick box that hosts several interesting temporary exhibitions each year. On the upper floor there is a permanent exhibition of Woking's history that is frequently updated by a number of enthusiastic volunteers. One of these is always stationed at the entrance to the building to help visitors.

On the ground floor a café is provided for visitors and a volunteer guide is always available to help. The Lightbox is closed on Mondays but is open the rest of the week and offers its permanent facilities for free. A £5 annual pass is available for those who wish to visit the temporary exhibitions.

Living Planet Centre

Opposite the Lightbox is the headquarters of the World Wildlife Fund. Set beside the Basingstoke Canal, the Living Planet Centre links the urban and rural environments by the use of landscaping. It aims to be as 'green' as possible by retaining many of the trees on the site. The centre was opened in November 2013 by Sir David Attenborough, who was impressed by the use made of the new building. The four interactive zones, designed by Jason Bruges Studio, each focus on a key theme – forests, rivers, oceans and wildlife. Each zone has a number of touchscreens, which are popular with both adults and children; school groups often visit and explore the work that is on the curriculum in more detail.

As is to be expected, this environmentally friendly building is heated through a system of earth ducts and ground-source heat pipes. Natural ventilation is helped by the wind-cowls on the roof and solar panels reduce the need for electricity. Rainwater is collected and 'grey water' from sinks is reused.

Films and soundtracks aid the atmosphere. Visitors can take a guided tour to find out more about the construction of the building and the area. Primary-school groups can take part in workshops and visit the learning ones. The centre is also an ideal venue for meetings, product launches and workshops as it offers a number of rooms with flexible space.

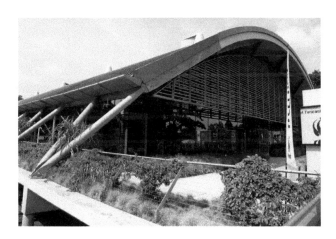

WWF Living Planet.

7. Murder and Mayhem

Over the years, Woking has had its fair share of tragedy. There have been a number of dramatic murders, so *Secret Woking* merited a 'murder' chapter. However, not all the deaths were murders. Suicide and unfortunate accidents also appear. The twentieth century saw several tragedies resulting from Cupid's arrow finding its mark.

Suicide Pacts

In January 1902 a porter at Woking Station made a gruesome discovery. When the train from Portsmouth stopped on its way to Waterloo, he noticed a hole in one of the windows. At first he assumed that a stone had been thrown through it. However, there was glass on the step board, and so he realised the glass had been broken from the inside. Puzzled, he opened the door and stared in horror.

A man, lying on the seat, was covered in blood and a woman, kneeling beside him, was equally splattered with gore. Both were still alive so help was hastily summoned and the pair were taken to the Victoria Cottage Hospital, but both died soon afterwards. The police later found a small revolver and a bag of cartridges near the bodies. There was no doubt the deceased had deliberately taken their own lives.

At the inquest held in the Albion Hotel, the reason for the suicide pact became clear. Forty-five-year-old Henry Scott was married but had been having an affair with twenty-nine-year-old Annie Cooper, who was single. Both became deeply unhappy at the deceitful lives they were leading. Eventually, they could bear it no longer.

On the fatal day, Henry bought a revolver and bade an affectionate farewell to his wife and daughter in Portsmouth – he knew he would never see them again. He wrote to Lillie, his wife, asking for her forgiveness for 'our sin' and apologising for having 'ruined your happiness'. Annie also wrote to her mother, with whom she lived, asking for 'forgiveness for the thing I am about to do'. She said, 'I am leaving this world with the only man I have ever loved.'

The jury took only ten minutes to reach a verdict of 'wilful murder'. The couple were buried together in Brookwood Cemetery after a short service. Henry's wife apparently forgave her husband as a wreath on his coffin was from his 'sorrowing wife, Lillie'.

There appeared to be no reason for another suicide pact several years later, in July 1934. Once again the railway was involved but on this occasion two mutilated bodies, obviously crushed by a train, were discovered by a passer-by on the railway line between Brookwood and Woking. It appeared that this, too, was a suicide pact as the right hand of the man had been tied to the left hand of his girlfriend.

The man was later identified as thirty-one-year-old Reginald Collyer. The girl, twenty-year-old Winifred Colclough, a domestic servant, was three months pregnant. Perhaps it was the shame of this that caused them to take their own lives. However, at the

inquest no reason was found for the suicides so the coroner decided that the couple were 'temporarily of unsound mind' when they planned their deaths.

Crimes of Passion

Susan Chappell was a talented musician who lived in Woking with her parents. In the late 1970s she took a summer job in Bognor Regis at Butlin's Holiday Camp. There she met John Lennox, a baker from Durham, and fell in love with him. They married and the couple set up home in Durham. At first they were happy and Susan gave birth to a baby daughter.

However, she became depressed and secretly took a lover, John Willis, but their relationship did not last. When it ended, she accused him of rape. He was angry and soon after this, Susan disappeared. A nationwide search followed; it was thought she might be trying to return to her Woking home. It was not until two weeks later in May 1983 that Susan's body was found buried in a wood near her home. She had been shot twice. Nearby lay the body of her lover. He had left a confession: 'Our love could not have lasted but I shot the lying bastard. Rape – not guilty. Murder – guilty.'

Jeanette Tadd had only been married for ten months when she was viciously stabbed to death by her husband Adam. Theirs had been a whirlwind romance culminating in a marriage in January 1993. The couple lived with Jeanette's parents in Abbey Road, Horsell, but it was not long before there were problems. Adam suffered from depression and drank heavily.

When he discovered that Jeanette had become friendly with a driving instructor, Norman Black, he threatened to 'kneecap' him. He had already employed a detective agency to spy on his wife. Jeanette realised she had made a big mistake by marrying such a jealous, unpredictable man. She told Adam she was leaving him and moved in with her lover. Adam was furious and refused to accept that their marriage was over.

When Jeanette went to her parents' house to collect some clothes on 20 November, Adam was waiting for her with a flick knife. Inside the locked bedroom door, he stabbed her sixteen times. He then rushed out of the house past Jeanette's distraught mother, who went into the bedroom to find her daughter dying.

Adam Tadd was arrested at his brother's house in Hersham soon after the murder. At his trial he pleaded guilty to manslaughter on the grounds of diminished responsibility. He was jailed for five years.

Yet another 'crime of passion' was committed by a betrayed wife. Julia Davidson, a doctor, had met Jeremy Wright, another doctor, when they were both been working at Whipps Cross Hospital. In June 1979 they married and set up home in Hook Heath in Woking. Julia gave up her career to look after her husband and four children while Jeremy became a respected surgeon. In 1986 Fiona Wood was appointed as a medical secretary at Jeremy's surgery in Old Woking.

Jeremy and Fiona became close and in May 1994, when Julia heard about the affair, she was distraught. Grabbing a kitchen knife, she drove to the surgery and stabbed Fiona thirty-five times. Then, covered in blood, she went to Nuffield Hospital where Jeremy was working. She informed him that she had just killed his mistress.

Julia was arrested and charged with murder. However, this was later changed to manslaughter on the grounds of diminished responsibility. She was sent to prison for four years.

A betrayed husband committed yet another 'crime of passion'. After only two years of marriage, Ireneu and Paula divorced in 2002 and Paula was awarded custody of their son. She remained in the house in Camberley they had shared while Ireneu took up residence in a flat in Maybury Road, Woking. He saw his son frequently, but as a court order forbade him to go near Paula's house, he always collected the boy from a nearby garage. He was a jealous man and was furious when he heard a rumour that Paula had a new boyfriend.

Then, on a cold morning in January 2003, Paula took her two-year-old son to her ex-husband's flat. When she confirmed that she *was* sleeping with her new partner, Ireneu lost control. He dragged her into the house and stabbed her repeatedly. Then, picking up his son, he ran out of the flat.

Neighbours had alerted the police and they arrived soon afterwards. Paula's body was discovered on a bed covered with a bloodstained duvet. It was not long before Ireneu was arrested and charged with murder. At his trial in the Old Bailey, he pleaded not guilty as he said his wife had attacked him first and the charge should be manslaughter. The jury disagreed and he was sentenced to life imprisonment for murder.

A Headless Corpse

Very early on a Wednesday morning in March 1901, George Pucket, who worked for the railway company, was passing the railway line near St John's when he discovered a body on the line. Gruesomely, the head was some distance from the body. The corpse was eventually identified as a casual railway worker named Williams but nothing was known about him. At the inquest, held in the Railway Hotel, an open verdict was returned, as there was no evidence to show that the victim had committed suicide.

Child Murders

Twelve-year-old Winifred Baker's murderer was never found. She was a pupil at Goldsworth School and a member of the Nightingale Scouts. On 4 December 1912, with other girls, she attended a scout meeting in the Mission Hall in Walton Road. She left the hall with two of her friends and as they walked up Walton Road, a man called to them. He said that their teacher needed one of them. Foolishly, Winifred believed him and left her friends. She was never seen alive again.

Her body was found the next day. Her school scarf had been used to strangle her. As her underclothes had been torn, it was assumed that 'an outrage' had taken place. The police searched for her killer but he was never found. 350 of her fellow pupils attended her funeral service before she was buried in Brookwood Cemetery. Her nightingale hat, found near her body, was placed on top of her coffin.

Earlier the same year in March, another Winifred was strangled. She was only four and her two sisters, two-year-old Freda and fifteen-month-old Florence, were also strangled. This was a particularly unpleasant crime; not only was the murderer their mother but she showed no remorse for what she had done. Her children, she said, were 'better out of the way' and they were 'in heaven'. She had intended to commit suicide but was arrested before she could do so and charged with murder.

She was found guilty but declared insane, so was sentenced 'to be detained as a criminal lunatic at His Majesty's pleasure'.

Another mother who strangled an unwanted baby was twenty-year-old Ellen Gregory. She worked at the White Hart Inn in Old Woking and lived with her parents. When she became unwell, the district nurse was called. Ellen, who had the mental age of a twelve-year-old, said she had a miscarriage. However, having examined her, the nurse discovered that the girl had just given birth but there was no sign of a baby.

Eventually, the newborn was discovered under the mattress. It had been strangled with a coat belt. Ellen was charged with murder. She pleaded not guilty and, considering her mental state, the judge sentenced her to twelve months in prison.

A Dreadful Accident

Leaving loaded guns unsecured can lead to tragedy, as it did on an April morning in 1910. Housemaids Maggie and Alice were in the pantry of their employer's house; they were making up a bed for Harry, the footman, who slept in the pantry. He did this because the silver was stored there and it was his responsibility to guard it.

He therefore kept a loaded gun in the drawer beside his bed. Unfortunately, on this particularly day, the drawer had been left open and the gun was in full view. When sixteen-year-old houseboy Richard came into the room, he saw the gun and picked it up. Assuming it was unloaded, he pointed it at Alice shouting 'Hands up!'

She laughed and, as she raised her hands, he pulled the trigger. A bullet flew across the room and Alice collapsed. Screaming, Maggie rushed out of the room for help. Alice was hurriedly transported to the cottage hospital where a surgeon tried to remove the bullet from her head. Sadly, he was unsuccessful and Alice died. At the inquest, the coroner decided that the tragedy had been a dreadful accident. He described it as a 'sad case' and reminded his audience that guns must be kept secure at all times. Poor Richard was distraught and left the court weeping bitterly.

Mistaken Identity

The murder concluding this chapter was one of mistaken identity. Alison Ponting worked for the BBC World Service. In 1988 she married a Russian art dealer and they set up home in England. In March 1993 he was sentenced to two life sentences for two murders ordered by the Russian KGB.

The following year Alison went to stay with her sister, Karen Reed, in Woking. The police felt that she was in danger from Russian gangsters and installed security equipment and panic alarms in Karen's house. Karen was warned not to open the door to strangers but on 30 April 1994, she forgot and opened the door without checking her visitor. The gunman fired six shots and Karen died instantly.

The murderer was never caught and the police were certain it was a professional killing and the intended victim was Alison. The funeral was surrounded by tight security and the bereaved sister followed the coffin wearing a thick black veil to hide her grief and identity.

8. Eating And Drinking In Woking

Woking is a multicultural town and this is reflected in the variety of eating places catering for all tastes. Over the past few years a plethora of new places to eat and drink have opened. There are the famous names including Café Rouge, Carvaggios, Cote Brasserie and Bill's. Customers can sample fare from around the world – Spanish, Italian, Chinese, Thai, Indian and Mexican. Familiar coffee shops abound – Pret a Manger, Costa, Starbucks, Café Nero, and Poppins. MacDonald's has replaced Robinson's department store in Chertsey Road while Burger King can be found in the Peacocks. A 'Beer Festival' is also held. A book about Woking today would not be complete without a chapter on 'eating and drinking'!

Bread

Bread has been the staple diet of this country for many years and bakers have worked hard to perfect the type of bread their customers enjoy. During the early part of the twentieth century, white bread was popular and bakers added various chemicals to their dough to make the bread as white as possible. During the First World War, this practice was discontinued and in 1916 white bread was banned altogether. A darker, healthier, wholemeal loaf was produced using barley, oats and rye.

After the war, customers again demanded white bread and bakers reverted to the use of chemicals. However, Mr Holroyd, a local miller, felt that the chemicals were harmful. To prove it, he fed the mixture to his dog, which became ill as a result. A local councillor agreed that 'there should be no sophistication of foodstuffs' and he deplored the 'tinkering' with bread.

Heater's Bakery

Mr Sherlock was a builder but he was also a businessman. With Woking expanding in the latter part of the nineteenth century and more shops opening, he decided that the town needed somewhere permanent to buy bread. In the past, bakers had usually been mobile and taken their wares around to houses and shops.

In 1869 Mr Sherlock built a bakery and shop in Church Path on the site of the present council offices. Here visitors could buy freshly baked bread and delicious cakes from the Health Bakery. Later, it was taken over by a Mr Bungy and there was one other owner before Frederick Heater bought the bakery in 1943. It flourished under his guidance and more shops were opened. The name was changed to Heater's and the company is still run by the Heater family. The current director is David Heater, Frederick's son.

Today the main bakery is in Bisley and there are several Heater's in the area, including one in Guildford Road in Woking. Described as Heater's, the Baker & Sandwich Maker, visitors can enjoy a wide selection of cakes, Danish pastries, sandwiches and other freshly baked delights.

Woking Food and Drink Festival

The Woking Food and Drink Festival was first held in 2013. Since that time it has expanded and the fourth one, held on the weekend of 2–4 September 2016, was more ambitious than ever. A tent village incorporating eighty food and drink exhibitors stretched across the town centre. There were demonstrations by the Tante Marie Culinary Academy, celebrity chefs including the Baker Brothers, Jane Devonshire, the *Master Chef* champion of 2016, and John Whaite and Rosemary Shrager, the presenters of ITV's *Chopping Block*. Woking has a number of excellent restaurants and the festival was an occasion for them to tempt customers to sample their wares. A variety of stalls sold freshly prepared dishes from around the world and there were interactive activities for all the family.

Woking Food Festival.

Auntie Anne's Pretzels

Auntie Anne's Pretzels can be found in the town mall, the Peacocks Centre. The 'Pretzel' has an interesting history; tradition suggests that it was invented by an Italian monk in the seventh century. He was very fond of children and, if they had learnt their prayers, he gave them a reward. This consisted of overlapping strips of dough folded to represent 'praying hands'. He called his 'rewards' 'pretiola', which means 'little rewards'.

'Brezels' were introduced into Germany where they became traditionally associated with Lent and Easter. On Easter morning children would go on a 'brezel hunt'. The popularity of this sweet 'treat' spread and in the eighteenth and nineteenth centuries, immigrants from Germany took the 'pretzel' to North America.

In the twentieth century an American businesswoman, Anne Beiler, made the pretzel internationally famous. She was born in 1949 in Pennsylvania, one of eight children. When she was three, her parents became members of the Amish Mennonite Church. As she grew up, Anne became the baker and bread maker for the family. She had left school early and concentrated on baking, which she loved. She worked on a food stall at a farmer's market near her home where she learnt to make pretzels in the Pennsylvanian-Dutch style.

In 1987 she started selling her own hand-rolled pretzels at a market stall in Maryland. The following year she rented a stall in Downington, Pennsylvania. She called it 'Auntie Anne's Pretels'. At first, her offerings were not enjoyed but she persevered and adapted the original recipe to create her own distinctive brand. Within a year, she had opened her first store in a shopping mall. By 1989 'Auntie Anne's Pretzels' could be found throughout central Pennsylvanian. Her fame spread and today she has pretzel shops not only in the US but also in Europe, including the United Kingdom. A devout Christian, she kept the original pattern of 'praying hands' but decided that the twisted strips represented angels' wings, above which she placed a halo.

Aunty Anne's Pretzels.

Auntie Anne's Pretzels opened in Woking in June 2015. While sitting at one of the tables, customers can enjoy a coffee and a pretzel that will be freshly baked and comes with a 'thirty-minute pretzel freshness guarantee'. Behind the counter Pradeep Sharda can be seen kneading a variety of shapes with the strips of dough before slotting them into the oven. Auntie Anne keeps up with the times. Each table has wired and wireless power charging stations and power socket units.

In 2013 Anne Beiler took part in the television series *The Secret Millionaire.* She masqueraded as a 'volunteer' in Baltimore charity Moveable Feast. Once unmasked, she donated a sizable sum to the charity.

Fuel

Next to the pretzels is Fuel. Having been 'naughty' with delicious pretzels, the customer can 'fuel' his or her body with a delicious selection of juices. A notice encourages passers-by to 'fuel your life' by indulging in a tasty drink while standing in front of the counter or walking with it into the Peacocks.

Tante Marie

The UK's oldest independent cookery school, Tante Marie came to Woking as the Tante Marie Culinary Academy in 1954. Since then it has offered a variety of courses for aspiring chefs. For those who wish to make hospitality their career, there is a two- or three-term Cordon Bleu Diploma covering all areas of professional cookery. For those planning to go to university, there is a useful gap-year course providing school-leavers with a valuable set of life skills, which will prove useful when they have to fend for themselves. The courses range from a one-week beginners' course to the ten-week Cordon Bleu Certificate. These courses can count towards the Duke of Edinburgh Award.

The academy also offers a number of lifestyle courses. These short courses run during evenings and weekends and cater for all abilities. They cover a wide range of culinary subjects from an Indonesian banquet to a creative Christmas. The 'Teaching Kitchen' can accommodate a maximum of eight students and there are even children's cookery classes.

Tante Marie.

In April 2015 the Tante Marie restaurant opened. Here, graduates of the Cordon Bleu Diploma continue their training while working towards the Level 5 Culinary and Hospitality Management Diploma. As well as serving the public delicious food, they learn skills that, in the future, will help them to run their own establishments. Every day, except Sunday evenings, the restaurant serves lunch and dinner. At the weekends guests can also enjoy a 'brunch'. The restaurant can also be booked for private events including children's parties and wine tasting.

The food is delectable, the service excellent and Tante Marie is proving a popular venue for a meal out.

Patisserie Valerie

Belgian-born Madame Valerie decided to introduce a taste of the exotic to England's 'plain fare'. In 1926 she opened her first 'Patisserie' in Frith Street, London. Its popularity was immediate and many more 'Patisseries' soon appeared in other parts of the country.

In September 2013 Patisserie Valerie opened in Wolsey Place, Woking. Here, sitting in comfortable armchairs beside full-length windows, customers can study the 'cosmopolitan delights' on the extensive menu. There is much to tempt at any time of the day. Continental breakfasts comprising various croissants, Danish pastries, toast and cereals start the day. However, an English café would not be complete if it did not offer a 'Full English Breakfast'. In Woking, Patisserie Valerie offers an 'All Day Breakfast & Brunch'.

Plenty of variety is also available at lunchtime. As well as 'grilled snacks', there is a two- or three-course set menu. During the summer months, there is even a separate 'Summer Menu'. Madame Valerie does not forget the children and provides an attractive menu just for them. At tea time customers can indulge in a 'Madame Valerie Cream Tea'.

Patisserie is, of course, French for 'pastry' and it is for these that the café has achieved its international reputation. The 'Patisserie Menu' illustrates some of the delightful concoctions that can be eaten in the café or taken home to enjoy later. Cakes for special occasions can also be made and, today, these can even be ordered online. Woking is privileged to boast one of these world-famous 'Patisseries'.

Patisserie Valerie.

9. Woking at Leisure

Since the beginning of the twentieth century, Woking has always had a reputation for enjoying the theatre. It therefore attracted a number of prospective thespians.

Strolling Players

In July 1902, Henry Robert King noticed an area of wasteland near Church Road. He decided that it would be an excellent site to erect his temporary theatre. With his 'strolling players', he erected a square wooden structure and covered it with a canvas roof. A small stage at one end and a few benches for the audience completed his 'theatre'.

Woking residents were delighted to pay 6d to sit on a bench or 3d to stand. The play was *Lost in London*, in which the proprietor, Henry King, played one of the roles. It continued to attract audiences but after a month, one of those watching was a police officer. Sergeant Arney was walking his beat in Church Street when he noticed the new building. Going closer, he joined the audience to watch.

However, at the end of the play he asked Mr King if he had a licence to perform in Woking. The proprietor said he did not think he needed one as they were 'strolling players'. When assured that he did, Mr King applied to the council but his application was rejected. He was taken to court and fined 40s for performing without a licence.

The Empire Theatre

Another similar theatre, made of wood with a canvas roof, was erected on wasteland in Duke Street a few years later. In June 1908 Mr T. E. Little, the proprietor of the new Empire Theatre, applied for a licence to perform. The council refused his application but, nothing daunted, he decided that, like Mr King before him, his group were 'strolling players' and, as such, did not need one. For three months the group played to full audiences.

It was not until the beginning of September that the authorities caught up with them. Mr Little was summonsed for staging a play in an unlicensed theatre. He pleaded not guilty but the court was not impressed and he was fined 20s with 19s costs. To the dismay of prospective audiences the theatre was closed and dismantled. Mr Little and his group of eighteen 'strolling players' moved on.

Christ Church Hall

Following the abortive attempts to establish a theatre in Woking, music and drama groups used the Church Hall belonging to Christ Church, the town church. A stage with curtains and a proscenium arch had been established at one end and rather uncomfortable wooden chairs were set out for the audiences. As this was the only large hall in the vicinity, it was also used for meetings and conferences.

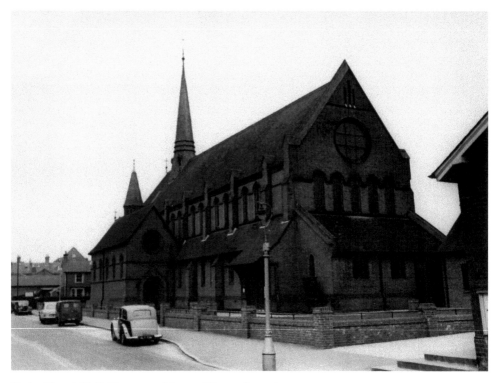

Christ Church Hall. (Courtesy of Surrey History Centre)

The Rhoda Mcgaw Theatre

It was not until the 1970s that Woking acquired its first purpose-built theatre. This was part of the newly built Centre Halls Complex and seated 230. It was named after the first Labour Chair of Woking Council, Mrs Rhoda McGaw, elected in 1963. Known as 'a woman of the people', she worked tirelessly for the people of Woking during her time on the Council. She died in 1971. It was fitting that Woking's first theatre should be named after her.

The Ambassadors' Complex

During the latter part of the twentieth century there was more development in Woking. Centre Halls disappeared to be replaced with the very grand Ambassadors' Complex. This comprised the new Victoria Theatre, seating over 2,000, and six cinema screens. At the time there was some doubt whether the small Rhoda McGaw Theatre would survive. However, with strong public support, the developers retained the small theatre at the bottom of the complex. It continued to be used regularly by amateur dramatic groups and operatic societies.

A newly formed Rhoda McGaw Theatre Company celebrated the millennium in style. *Encore*, described as a 'stunning theatrical kaleidoscope', had a large cast of actors, singers, dancers and musicians. The show consisted of songs, dances and play extracts from the previous hundred years. The first night was on 28 December and it continued to play to packed audiences until 8 January at the beginning of the twenty-first century.

Ambassadors' Complex.

Horsell Amateur Dramatic Society

One of the groups that uses the Rhoda McGaw Theatre twice a year for its performances is the Horsell Amateur Dramatic Society (HADS). This was the first one of its kind to be formed in Woking. It was born in 1921 when, in June of that year, several thespians performed a play called *Our Flat* in Horsell to an invited audience. Its success led to the formation of HADS.

On 2 February 1922, the society's debut took place in Horsell Parish Hall. The audience wore evening dress to watch the comedy *The Man from Toronto* by Douglas Murray. It was described as 'a distinct triumph' and the society's reputation grew. Many would-be thespians applied to join but not all were accepted. One successful applicant who took part in several productions was the famous astronomer Patrick Moore, who, at the time, was teaching at St Andrew's Preparatory School in Horsell.

The Silver Screen

At the beginning of the twentieth century there was other entertainment on offer. In 1903 the first cinema, Central Halls, was opened with seats for 150. It proved very popular – even attracting a stray cow who wandered in from the local cattle market! It continued to pull in the crowds for many years but in the 1920s the population had grown and a larger building was needed.

Horsell Parish Hall.

The current cinema was enlarged and redesigned. In February 1927 the Plaza Cinema was officially opened by the chairman of the district council in front of a large crowd, including a number of public figures. Described as one of the best cinemas outside London, its large entrance hall had carpeted staircases on either side leading to a spacious balcony. The attractive colour scheme was complimented by unusual light effects. Prices ranged from a 1s to 3d.

The first film to be shown in the new cinema was *Mars*, a tribute to those who had lost their lives in the First World War. There was one performance each evening – on Saturday there was a matinee as well.

In 1913 another cinema opened on the corner of Duke Street and Maybury Road. Originally named the Palace Theatre Picture Palace, it later became the Odeon. The third cinema to open in Woking was the Ritz in Chobham Road. Built by Union Cinemas, it was officially opened on 12 April 1930 by Mr Godfrey Nicholson, the Member of Parliament for Farnham.

The new cinema even surpassed the Plaza in luxury – it was said to be 'one of the finest cinemas in the United Kingdom'. A Compton organ, which had been specially built, was installed at great expense. Modern projection technology was used and there was even air conditioning and central heating. The first film to be shown was *The Texas Rangers* followed by a comedy, *Wives Never Know*. On the floor above the cinema there was a restaurant, and

during the interval in matinee performances visitors could have afternoon tea brought to them in their seats. The restaurant was open all day for the public to patronise.

During the latter part of the twentieth century the cinema was closed and the premises were used as a Bingo Hall. In 1988 the building was demolished and replaced by an office block. The name Hollywood House is the only reminder of the 'silver screen'. However, with the advent of the Ambassadors', Woking still has a choice of six screens to enjoy a variety of films.

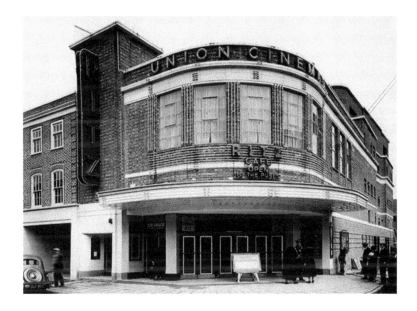

Ritz Cinema. (Courtesy of David Rose)

Hollywood House.

Gaumont Cinema.

The Atalanta Ballroom

Until 1972, the Atalanta Ballroom had been one of Woking's iconic buildings. Before it became a popular ballroom it had been a Methodist manse and then the YMCA headquarters. When it became a ballroom, it was redecorated in pale pink, and an excellent sprung dance floor replaced the original. A resident band enabled the Atalanta Ballroom to become a popular venue for dances, concerts and discos for many years. Over the years, it was also visited by other famous bands including the Rolling Stones, who provided the town with a night to remember in August 1963.

Sadly, in the 1970s the building was scheduled for demolition. There was an outcry from the public, many of whom had danced in the ballroom from an early age. A lengthy petition was delivered to the council in December 1970 but it was ignored and the building was demolished in 1972.

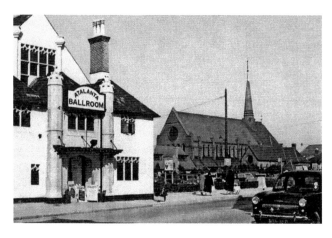

Atalanta Ballroom.

10. A Woking Miscellany

Woking, like most places, has had its share of strange or unusual happenings, so it seemed a good idea to use this title for the last chapter.

Floods

The nineteenth century started with the worst floods in the Woking area for over forty years. Old Woking became an 'inland sea' and some houses were submerged beneath several feet of water. A gaggle of geese took advantage of a house that had fallen into disrepair by swimming in one window and out through another! A horse, submerged in a field, had to be rescued by boat and water swirled into a nearby brewery, dislodging a number of beer barrels that floated down the High Street.

In 1910 Old Woking was once again flooded. Residents retreated with their possessions to upstairs rooms to wait until it was safe to come downstairs. Both pedestrians and cyclists were stranded and cars stalled when water seeped into their engines. An employee of Unwin's Printing Works, Benjamin Pitter, frequently helped stranded residents. When he died, aged seventy-five, during the current floods, his coffin had to be ferried through the water to the cemetery.

1928 was another year that started with 'the worst floods in living memory'. That year saw the heaviest rainfall ever recorded in the Woking area. Once again, Old Woking suffered badly. However, marooned residents were kept entertained by throwing bread from their upstairs windows to a family of graceful swans who were swimming up and down the High Street.

The First Car

It was 1907 when the first car appeared on the Woking streets. It was owned by Mr Whetman, the landlord of the Goldsworth Arms. He had bought it for £17 and delighted in driving it through the town at no more than the statutory speed of 20 mph.

The Man in the Iron Mask

On 1 January a man in Trafalgar Square, wearing an iron mask, pushed a perambulator past Nelson's Column. Crowds stared. To win a considerable sum of money, he had accepted a wager from an American millionaire to wear the iron mask and push the heavy baby carriage – without a baby – around the world!

He had already spent several weeks on his journey when he arrived in Woking where the residents were equally bewildered by his appearance. However, they were quite happy to buy his postcards and pamphlets describing his wager. The money he received from these paid his expenses as his 'sponsor' had stipulated that he was not allowed to accept anything free.

It is not known whether he won the wager.

A Letter from the Front

Many young men from Woking volunteered to fight for their country in the First World War. Sadly, many of them did not return. Nevertheless, one of them, a private in the 16th Battalion of the Rifle Brigade, sent the following letter to his aunt in 1914 describing an historic event:

We have a good deal to put up with out here but all the fellows including myself, are exceedingly cheerful about it. We do a good deal of singing; it is a cheering way of spending our unoccupied time as well as when on the march and in the trenches. We were in the trenches on Christmas Day and had a unique experience. Both sides came out of their trenches and met in the centre and exchanged greetings. This was not the general thing, I think, as we could hear firing on both sides of us.

Another Letter from the Front

Two years later, in 1916, a former curate from Christ Church, Woking, was serving at the front as a 'padre'. He wrote to members of the church asking them to 'send magazines books, games, eatables' for a club he had started for the men in his charge in the trenches. He wrote that the club 'is a great help to the men. Aeroplanes are a nuisance backed by the guns and do their very best to spoil our services in the open air. At present I am billeted in a farm and have a very strong objection to sharing my bedroom with rats but the rats refuse to see it in the same light'.

A Monster Visits Woking

Some Woking businessmen were concerned about the number of lonely young men in the town. They raised some money and in March 1931, a YMCA centre was opened in Bath Road. Young males of sixteen and over were invited to 'make it [their] home for leisure hours and to say goodbye to lonely evenings'.

The centre was a success but more money was needed, so some of the young men thought of an ingenious idea. Acquiring some canvas and paint, they spent a month creating a 40-foot-long prehistoric monster. They attached a notice on his back announcing that he would be returned to Whipsnade Zoo at a later date.

On Saturday 1 August they dragged the creature out of its 'den'. It was paraded through the streets by 'strangely dressed keepers' who persuaded passers-by to buy flags to support the YMCA. Refused entrance to the recreation ground by Woking Council, they 'parked' their charge in the town and played a barrel organ to entertain the crowds. They raised £50 for their cause.

Robinson's Opens

In 1934 William Robinson bought Alfred Wyles' Drapery shop in Chertsey Road and renamed it Robinson's. When he retired, his son David and his daughter Isabel took over the running of the store that also served as a women's outfitters. It was very popular – particularly with elderly women whose chauffeurs would drive them to the store and then go for a walk. A sales assistant would be summoned and she would climb into the car to measure the occupant for her corset.

Robinson's. (Courtesy of David Rose)

McDonald's.

On its upper floor, Robinson's also boasted an excellent restaurant. As it was the only one in Chertsey Road, shoppers made good use of it. The food was provided by the same catering firm that served Harrod's of Knightsbridge. The site is now occupied by MacDonald's!

Bees Stopped Play

One sunny afternoon in May 1936, St John's Cricket Club was playing the Lion Work's Club on St John's Ground. The only sounds were the crack of willow against leather and the occasional shouts of the players. Then the peace of the day was suddenly disturbed by an overhead droning sound that was getting louder.

Looking up, the players saw, to their horror, that a swarm of bees was heading in their direction. Abandoning bat and ball, the batsman, bowler and fielders flung themselves flat on the ground as the vast swarm of insects skimmed over the wickets before soaring up to fly over the tower of St John's Church.

Still stunned by their experience, the players staggered to their feet and resumed play. 'Bees stopped play' made a change from the usual 'rain stopped play'!

A Spy In Their Midst

During the 1920s more and more cars were appearing on the roads. An enterprising woman, Sybil Methold, decided to create a well-run service station for motorists that would blend in with the countryside. She found a suitable field covered with redcurrant bushes but with an oak tree at one end. Disposing of the redcurrant bushes, she designed her petrol station around the oak tree, which had a streak of pale-green lichen on its trunk. She decided on that colour for her eight petrol pumps and had special paint blended for her.

When the painting was complete, she planted bulbs in the forecourt. She also installed a shilling-in-the-slot machine for the convenience of motorists who were travelling at night. The petrol station opened at Easter in 1927 and was so successful that her husband gave up his own business to join her.

Methold Engineering Ltd played its part during the Second World War. New lathes and milling machines were installed and aircraft parts were produced. These were sent to factories that made aircraft. In 1942 two men worked as skilled machinists. There were sixteen female employees, many of whom were foreign. They had all been vetted by the Labour Exchange before being sent to work at Methold's.

However, the vetting had not been as thorough as it should have been. One evening a fight broke out between two of the women. One of them had scoffed at the idea of concentration camps in Germany. She declared that there were none. The other woman, showing the brand on her arm, flew at the scoffer screaming that she had actually *been* in a concentration camp in Germany.

The police were called and the women were escorted off the premises. The next day the concentration camp victim appeared for work. The other woman would not be returning as she was being detained 'at His Majesty's Pleasure' as a possible spy.

Woking's First Member of Parliament

On 23 February 1950 a general election was held. As a new Woking Constituency had recently been formed, it was necessary to elect a Member of Parliament for the first time.

There were three candidates representing the three main parties – Conservative, Labour and Liberal. A record number of Woking residents voted, and when the polling stations had closed, the sealed ballot boxes were taken to the police station and locked in a cell overnight. The following morning, under police escort, the boxes were driven to the Boys' Grammar School where counting took place in the hall; it lasted all day. By two o'clock, a crowd of people had gathered outside but it was not until five o'clock that they were allowed into the hall to hear the result. This was announced by the returning officer, the high sheriff of Surrey. The Conservative candidate Harold Watkinson won by a large majority and today Jonathon Lord is Woking's current Conservative Member of Parliament.

Marie Carlile Church Army Home

Wilson Carlile founded the Church Army in 1882. He moved to Woking in his latter years and lived in a house in Coley Avenue with his sister, Marie, after whom the house was named. Wilson Carlile died in 1942 and his sister continued to live in the house. In the 1950s it became a 'short stay Sunset Home for the aged and infirm'. Later it kept the name of the house and became the Marie Carlile Church Army Home. For over forty years, the home provided excellent care for the elderly residents and services were held in the small chapel every day.

At the beginning of the twenty-first century, the Church Army decided to close the home in spite of strong local opposition. A farewell service, led by the Vicar of Christ Church, was held in the chapel and tributes were paid to Church Army Captain Jim Etheridge and his wife Margaret, a nurse who had run the home for many years.

The site is now occupied by flats but the name 'Marie Carlile' appears on the entrance.

Marie Carlile. (Courtesy of Margaret Etheridge)

Flats on site of Marie Carlile.

The Lighthouse

The Lighthouse was the vision of Eric Jespersen, the pastor of the Vineyard Church. He wanted to help those in need. To this end, he opened a building in Old Woking where food and drink, practical help and listening ears were available to all. The project soon became very popular and outgrew its premises. A derelict building in the High Street, which had once housed Courts furniture store, became available. This was soon transformed by an army of volunteers into a vibrant hub for the local community and The Lighthouse opened in 2014. Its various activities are run by around fifty volunteers from Woking churches. Alison, the paid administrator, is a member of the Coign Church. The project is financed only by donations. It has many facets.

Jigsaw helps families in need by providing clothes, toys and equipment for preschool children. Replenish provides a food bank and emergency food parcels. It is the main food bank centre and stores a vast amount of donated food identified by type and date. As well as dispensing food parcels, food is also distributed to the two other food banks in the area – the Salvation Army Community Church in Goldsworth Park and the Mascot Hub in Sheerwater.

Restore offers life-skill workshops like bread making, coaching, Bible study and counselling. To encourage the sense of community there is also a 'drop-in centre', live music and a pop-up cinema. The Cosy, a coffee shop, is open on Mondays and Thursdays

until 12 p.m. This offers 'organic and artisan coffee, speciality teas and yummy food'. Those who serve are being trained as 'baristas'.[10.1] At the same time, those who are troubled can have 'A free Soul Consultation' where counsellors will listen and try to help. The counselling is done in 'a safe and welcoming environment' and all, 'regardless of beliefs, background or position', are welcome.

The Lighthouse describes itself as 'a social crossroads that supports the well-being of Woking'.

Barber's Auction House

John Barber set up as an antique dealer in Duke Street in 1920. Later, he changed to auctioneering. When his building was scheduled for demolition in the 1970s, he transported it to a site in Mayford where it still flourishes.

The entrepreneur also took up picture framing and, in 1977, Barbers Picture Framing took up residence in No. 18 Chertsey Road – the original home of Macfisheries. In 1986, the company was bought by Stuart Herring, who still runs it.

Barbers Auction House is now run by Keith Mansfield and holds regular auctions. In September 2012, a silver serving dish was sold for a record £30,000. In February of the same year a scraper board black-and-white picture of *Christmas Shopping Rush Ballyscunnion* by William St John Glen, an Irish painter and cartoonist, was sent to Barbers for evaluation. It had been donated by an anonymous donor to the Phyllis Tuckwell Hospice charity shop in Farnham. The manager thought it might be valuable so sent it for evaluation. The painting was discovered to be one of a collection produced monthly for a Dublin magazine over a thirty-year period from 1939 to 1969.

William Glenn's daughter had been searching for the missing painting and Barbers returned it to its rightful owner so that it could be reunited with the rest of the Glenn family collection. In gratitude, she donated £300 to the Phyllis Tuckwell Hospice.

Notes

1. **Old Woking**
 1. There will be more about Henry Drummond in Chapter Five.

2. **The Railway, the Cemetery and the Crematorium**
 1. 'Old Money': 12 pence = 1 shilling: 20 shillings = 1 pound: 21 shillings = 1 guinea.
 2. The Guildford Diocese was not created until 1927.

4. **Woking in the Twentieth Century**
 1. A 'fret' is a decorative pattern of straight lines.
 2. The author has been one of Kevin's clients for several years and has been delighted with the cars he has selected for her.

5. **Famous and Infamous Residents**
 1. A privy was an outside lavatory. The family would not have had a flushing toilet at this time.
 2. Kate Summerskill's book *The Suspicions of Mr Whicher* was made into a television programme in 2011.

10. **A Woking Miscellany**
 1. A 'barista' is an official 'coffee-maker'.

Bibliography

Clarke J. M., *The Brookwood Necropolis Railway* (The Oakwood Press: 1983)

Summerscale K., *The Suspicions of Mr Whicher or the Murder at Road Hill House* (Bloomsbury Publishing PLC: 2008)

Janaway J., *Haunted Places of Surrey* (Countryside Books: 2005)

Field M., *The Way We Were* (Fort Publishing Ltd: 2005)

Field M., *Woking: A History and Celebration* (Frith Book Company Ltd: 2004)